NINETEENTH CENTURY

London Reenvisioned One

GARY LEE KVAMME

Volume 5

Telling Art Series

Copyright © 2017 by Gary Lee Kvamme

All rights reserved.

Published July 2017

NINETEENTH CENTURY
London Reenvisioned One

A new, vibrantly colorful array of impressionistic paintings of landmark sites of nineteenth century London.

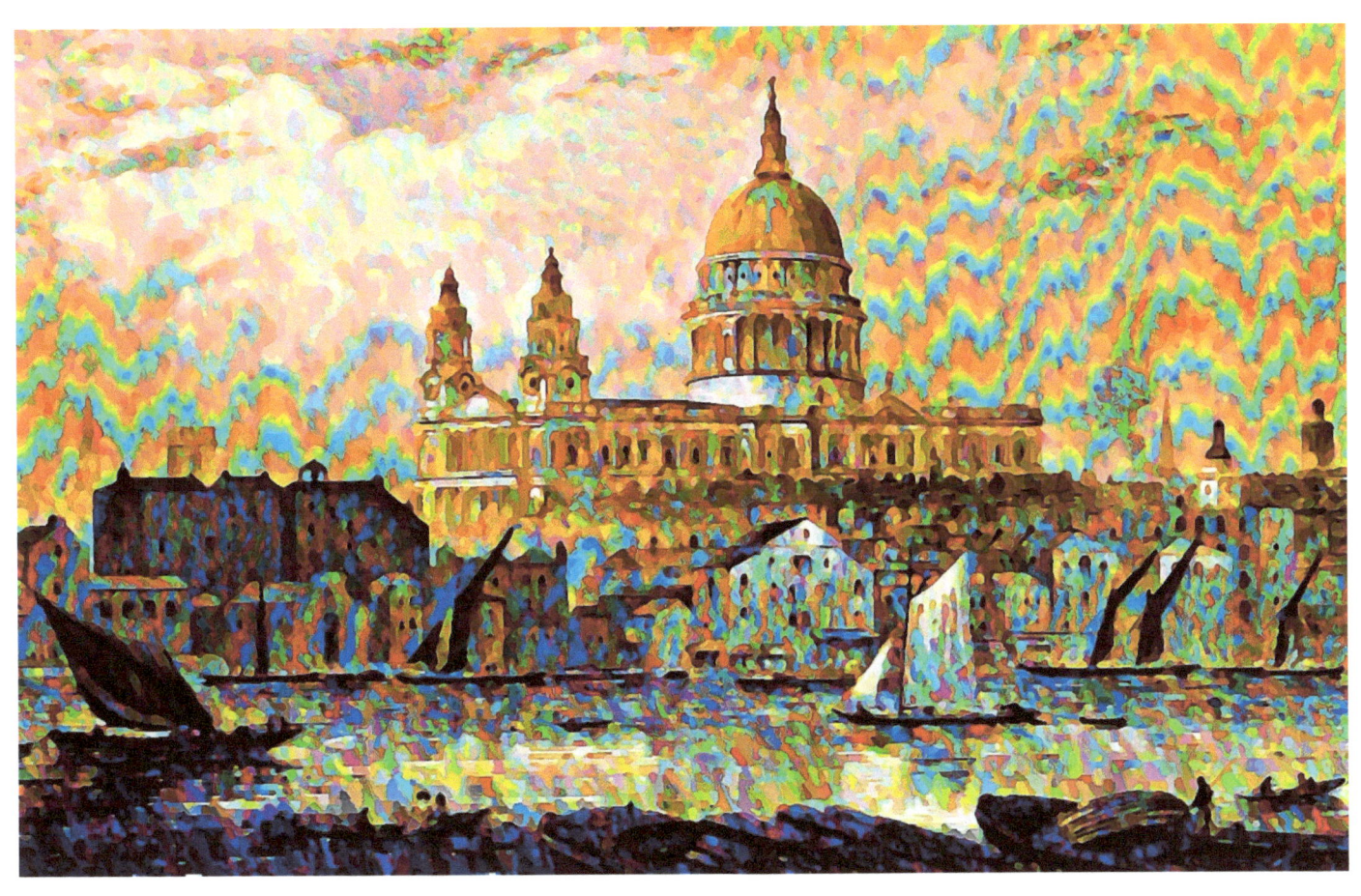

ST. PAUL'S CATHEDRAL, FROM THE RIVER.

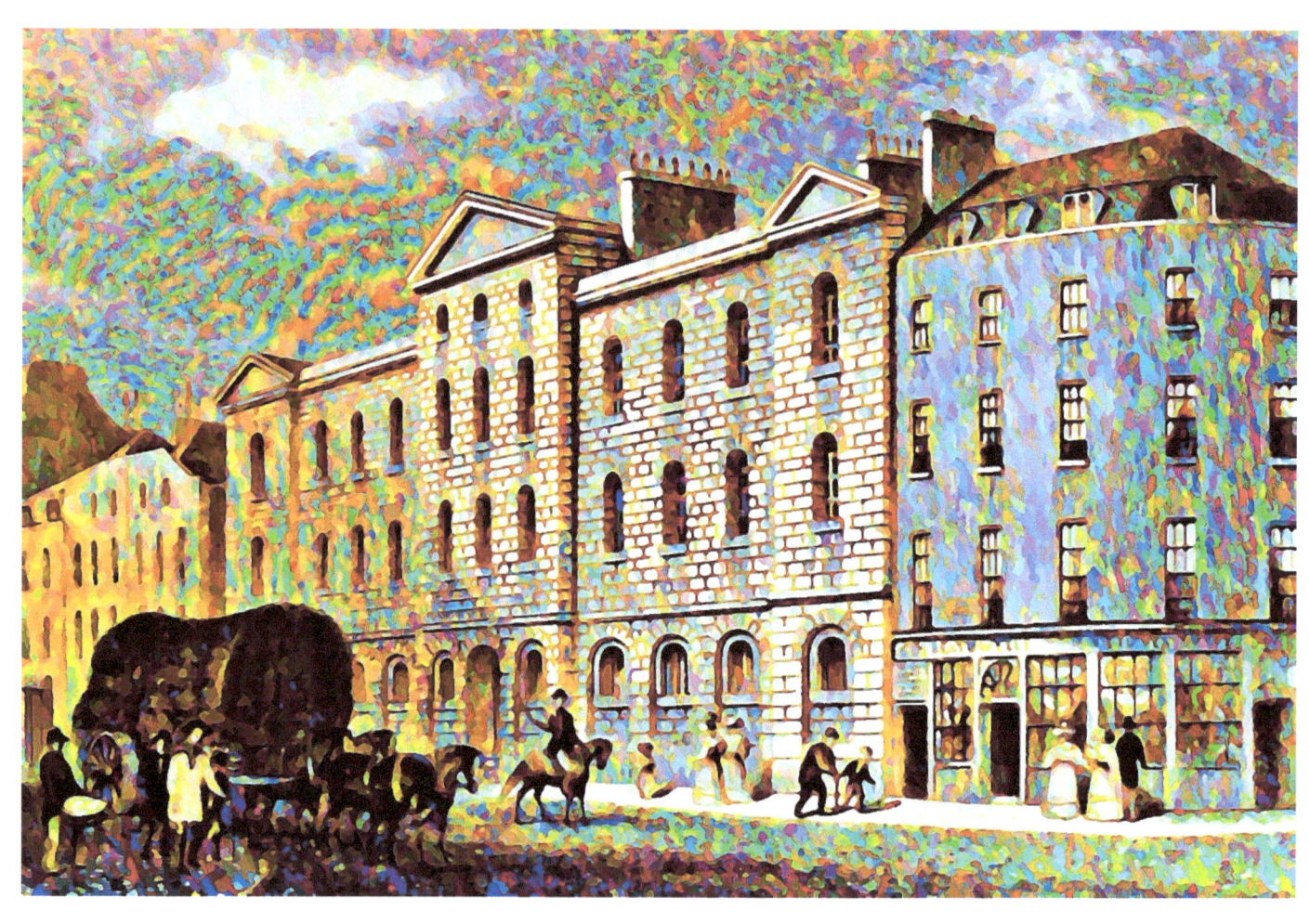

COMPTER, GILTSPUR STREET.

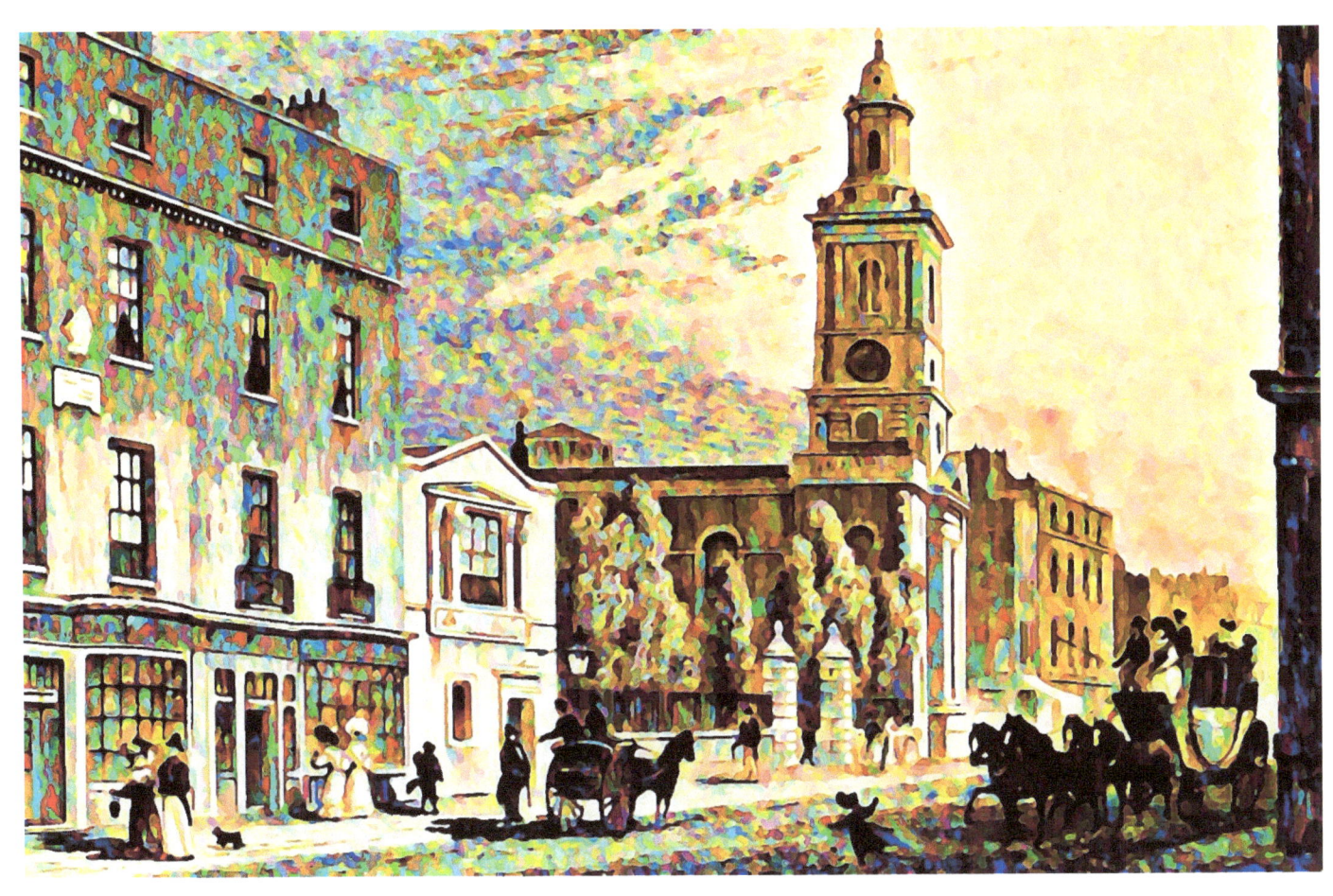

ALLHALLOWS CHURCH, UPPER THAMES STREET.

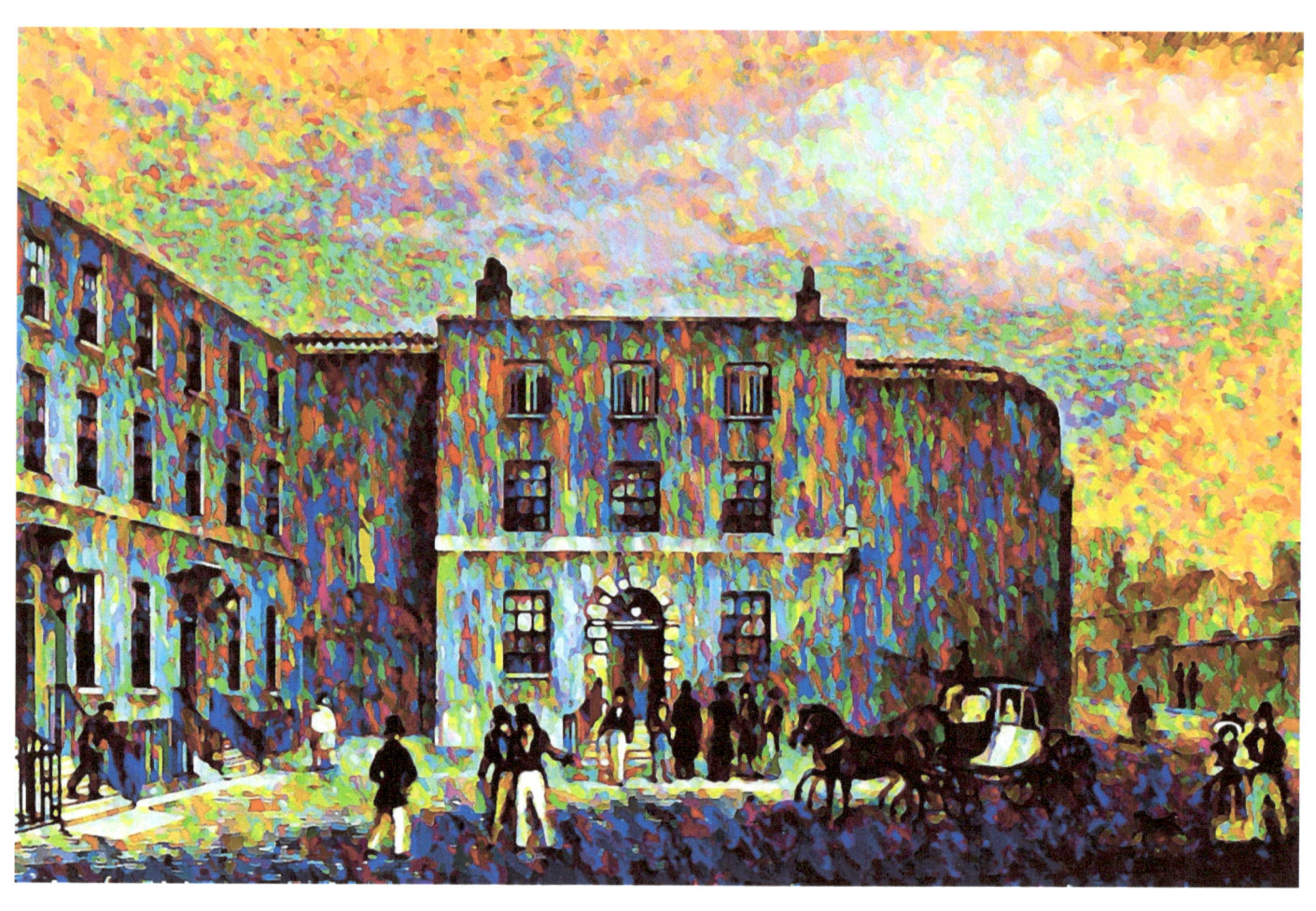

KING'S BENCH PRISON, PRINCIPAL ENTRANCE.

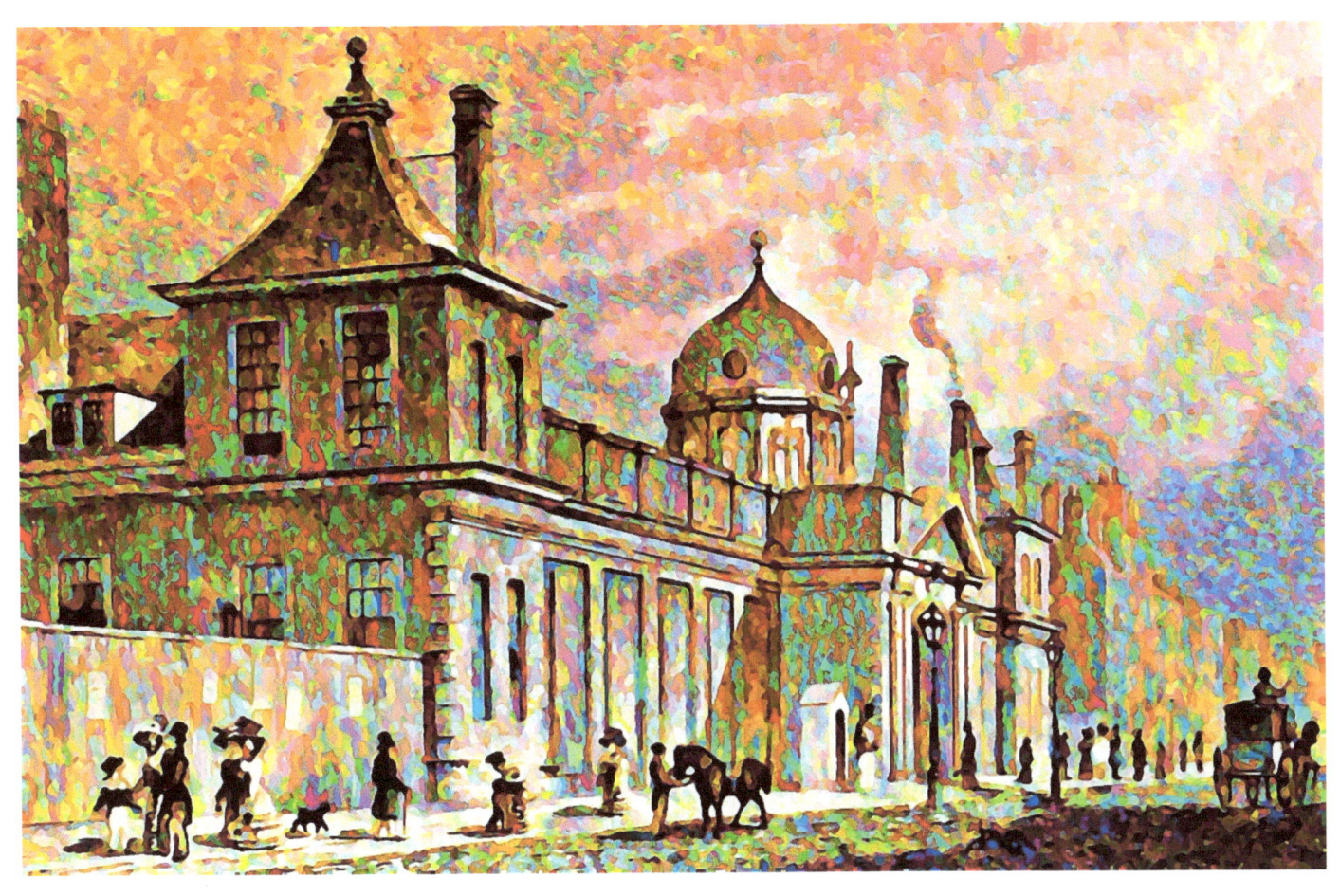

BRITISH MUSEUM, GREAT RUSSELL STREET.

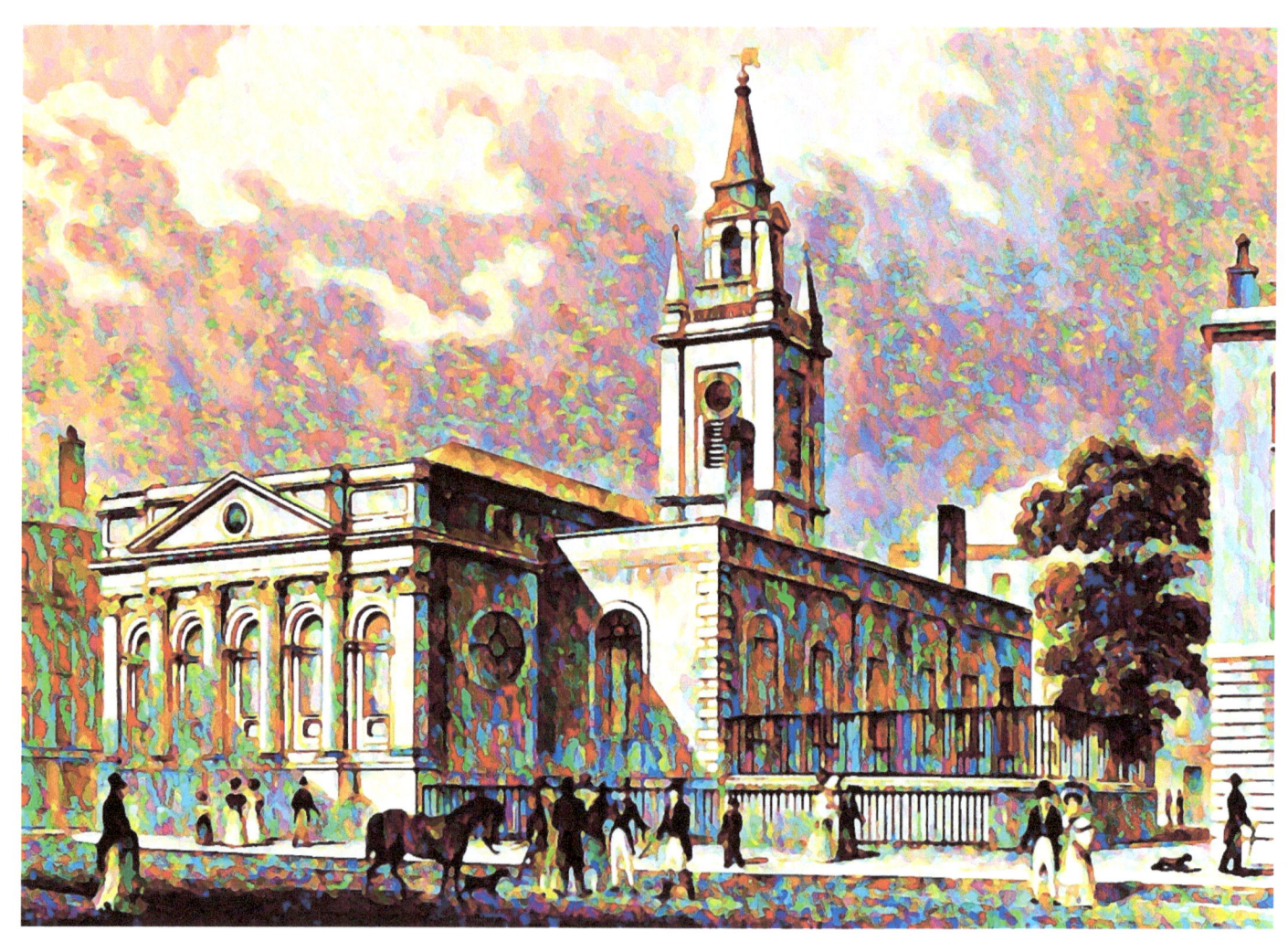

ST. LAWRENCE, KING STREET.

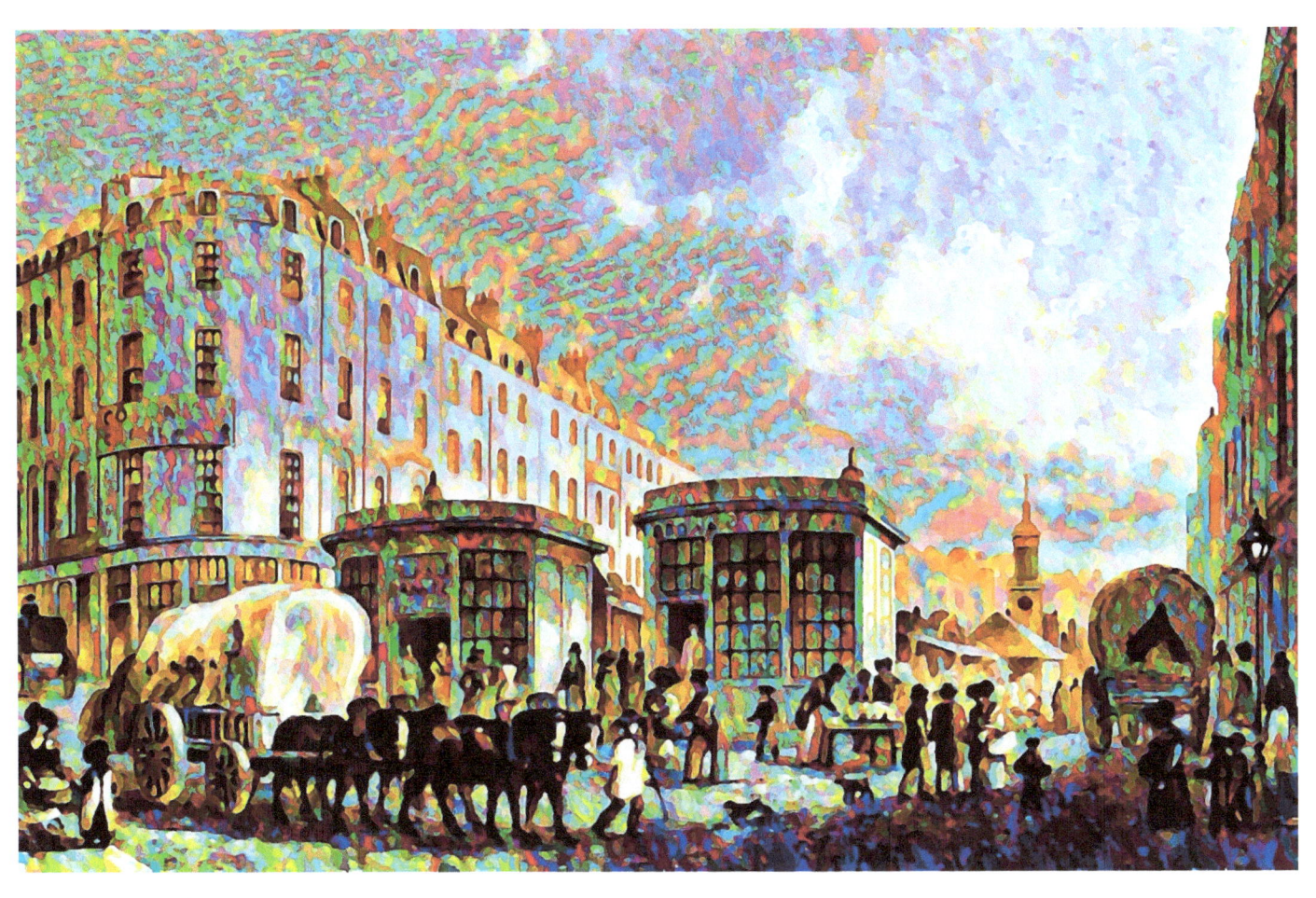

FLEET MARKET, FROM HOLBORN BRIDGE.

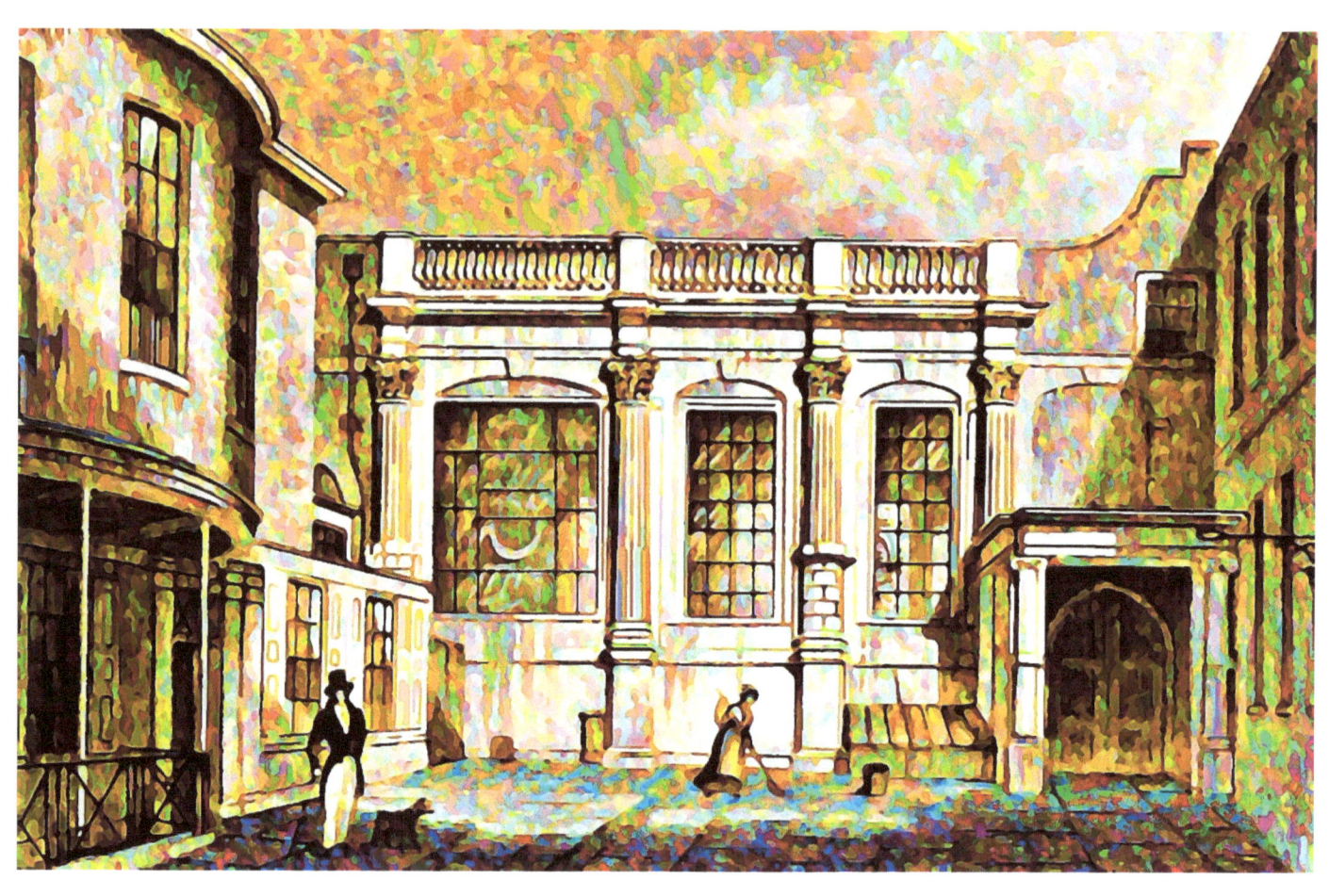

CLOTHWORKERS' HALL, MINCING LANE.

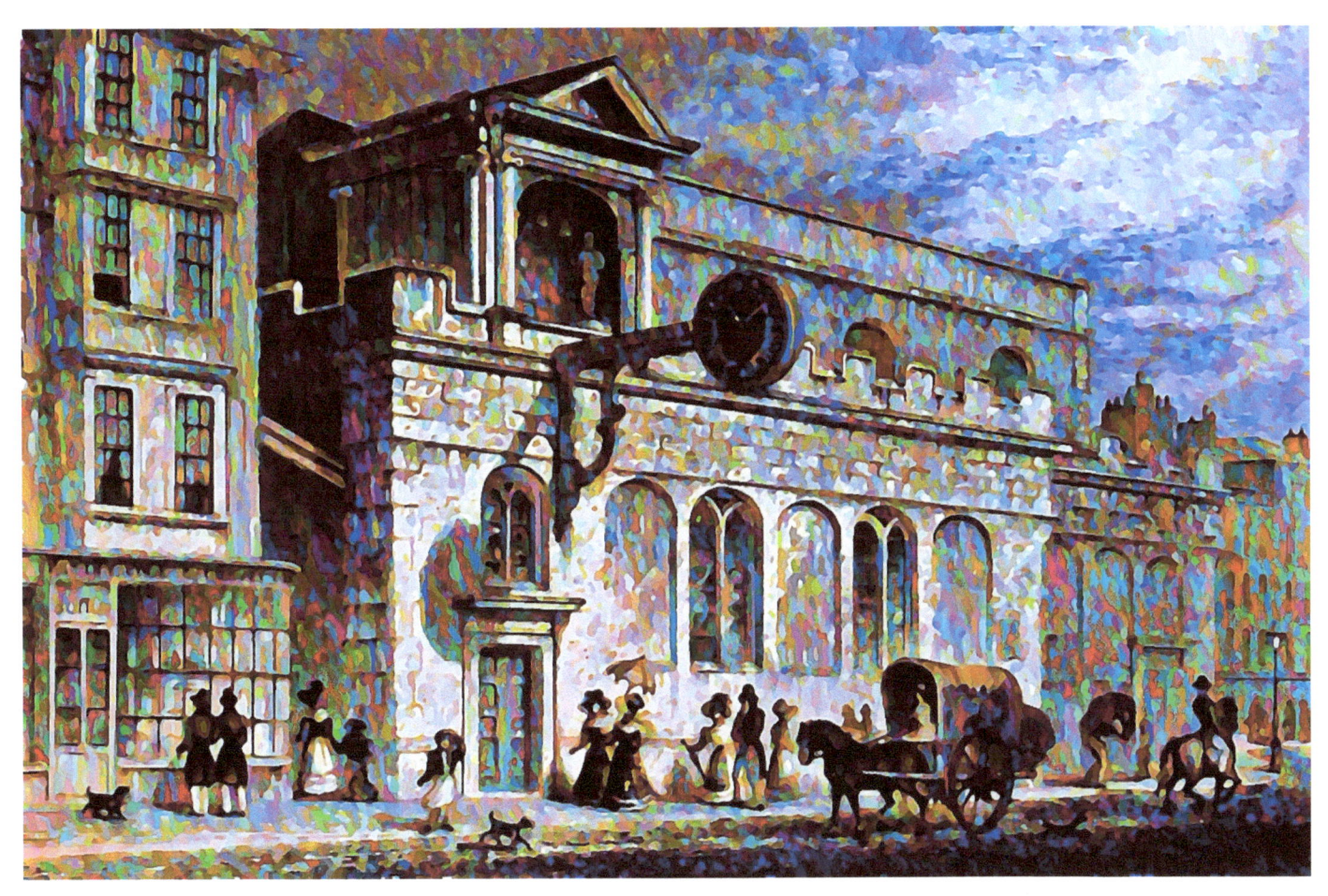

ST. DUNSTAN-IN-THE-WEST, FLEET STREET.

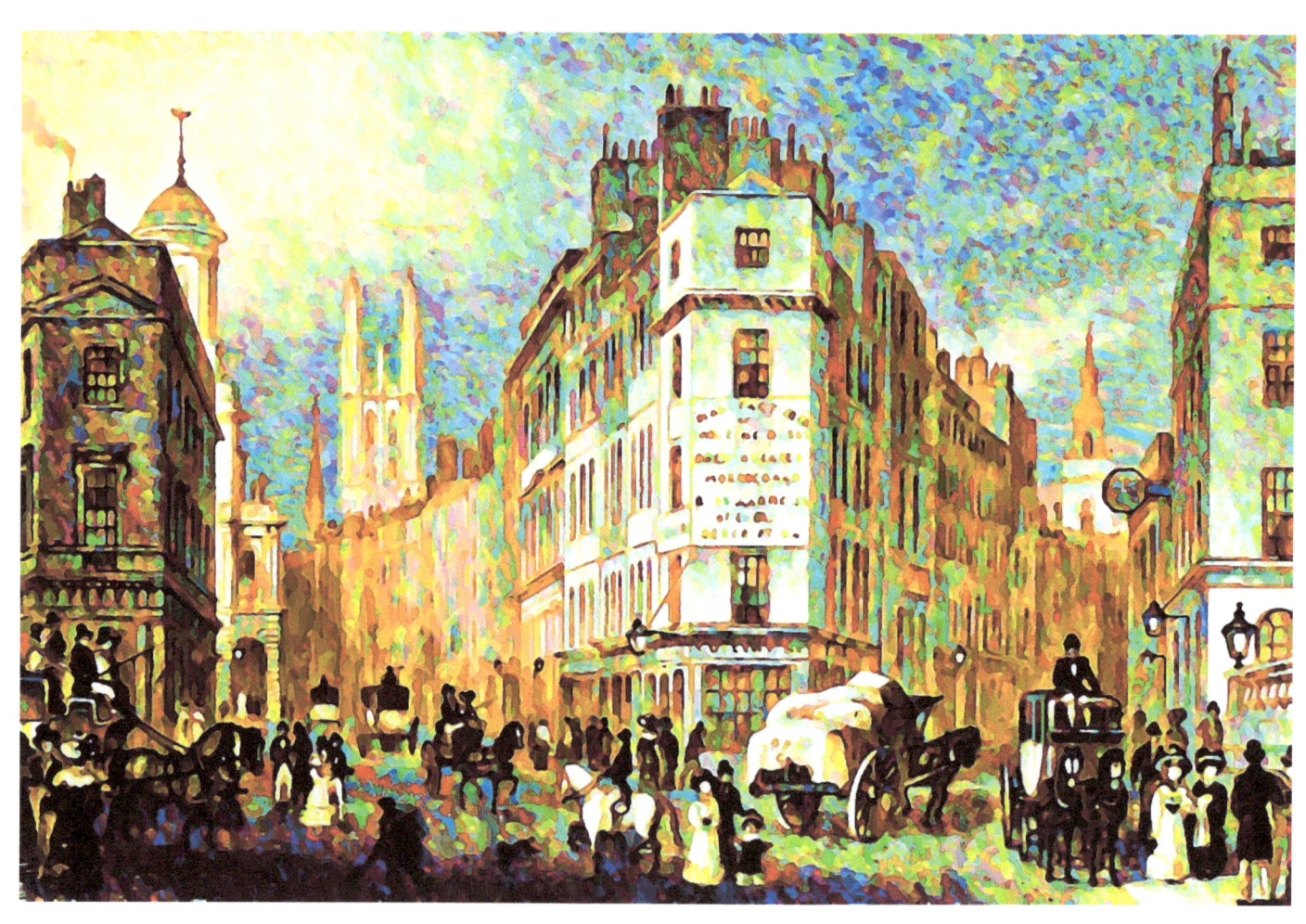

CORNHILL, AND LOMBARD STREET, FROM THE POULTRY.

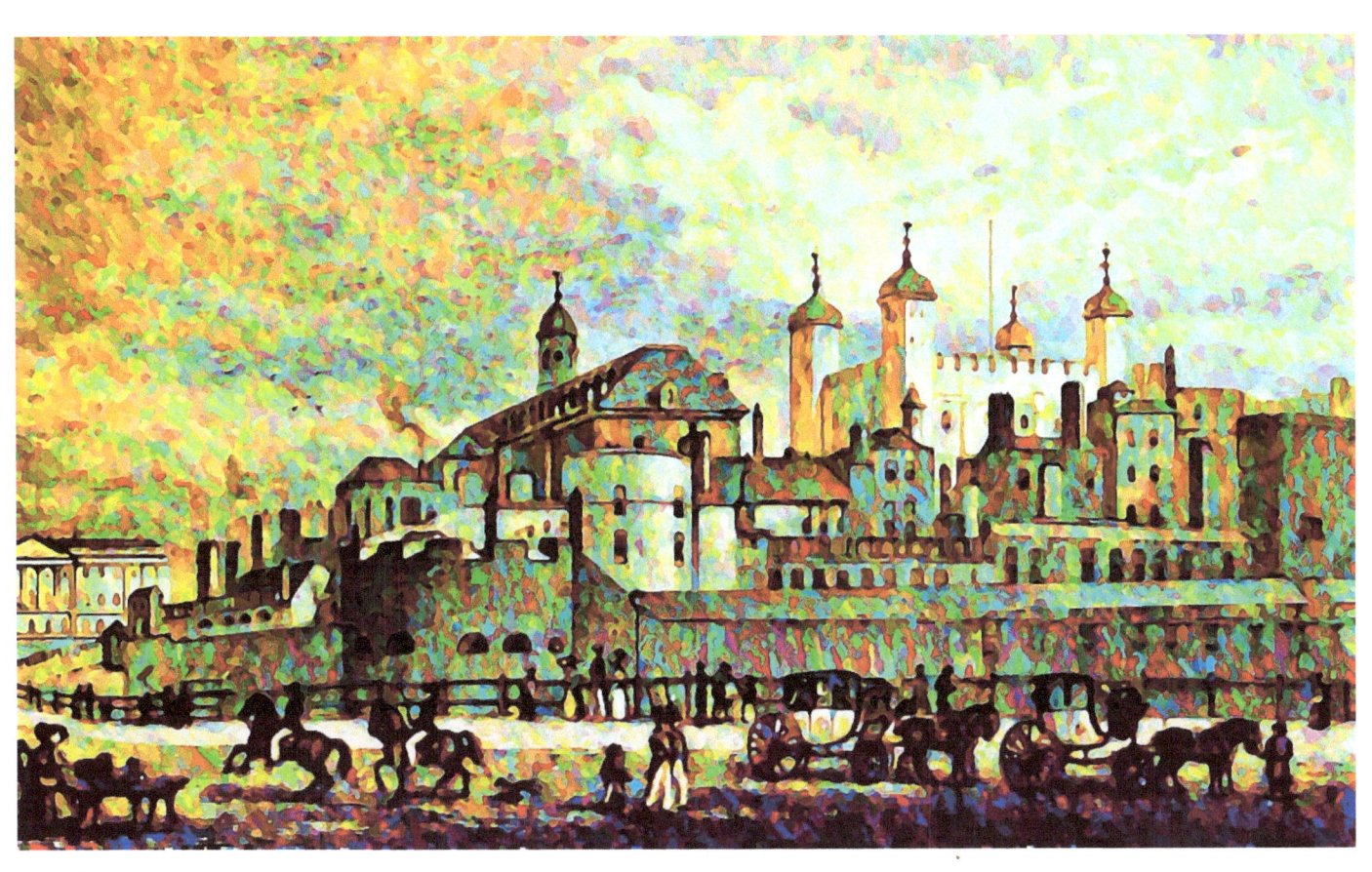

THE TOWER OF LONDON, FROM TOWER HILL.

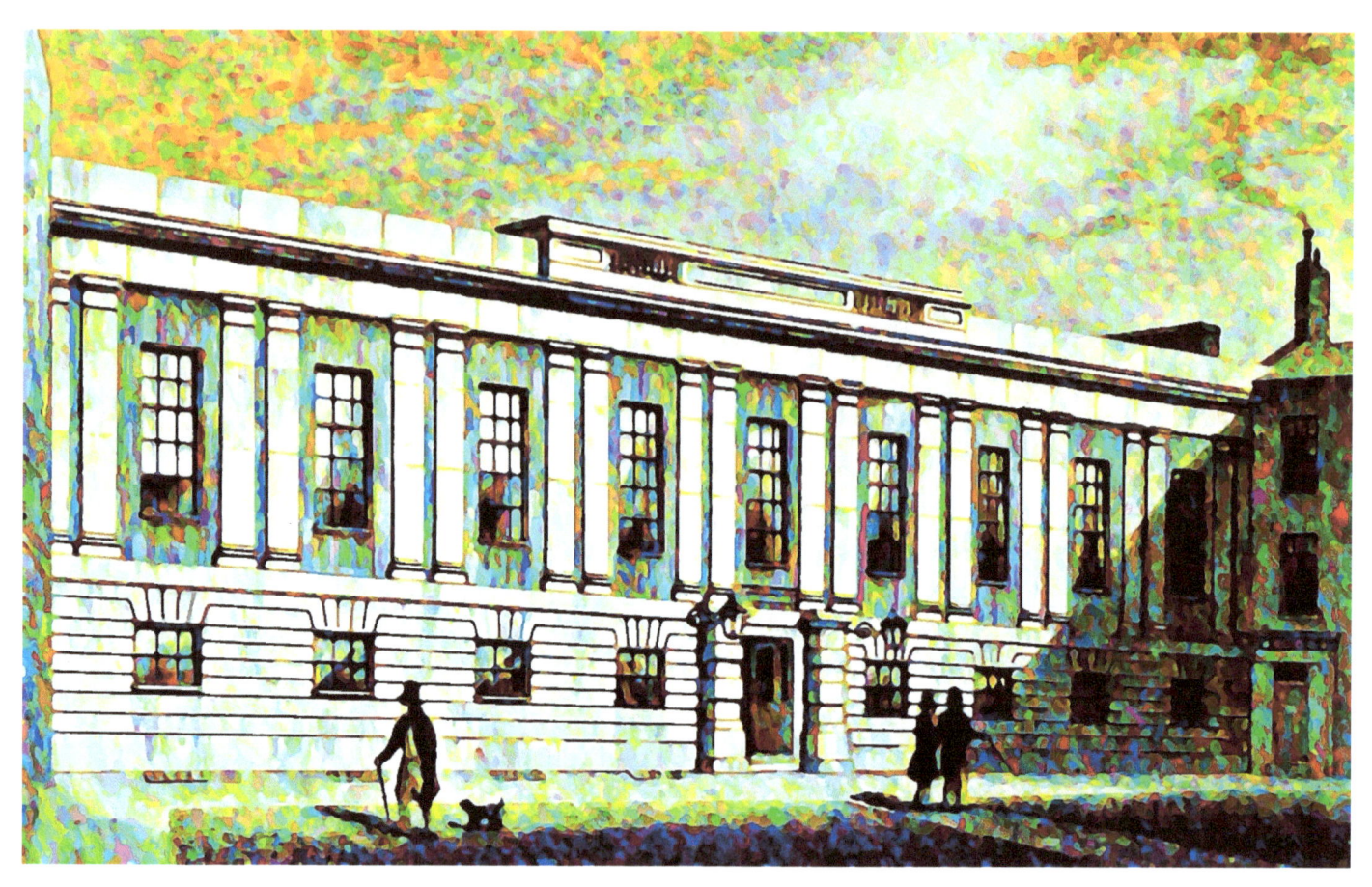

GROCERS' HALL, POULTRY.

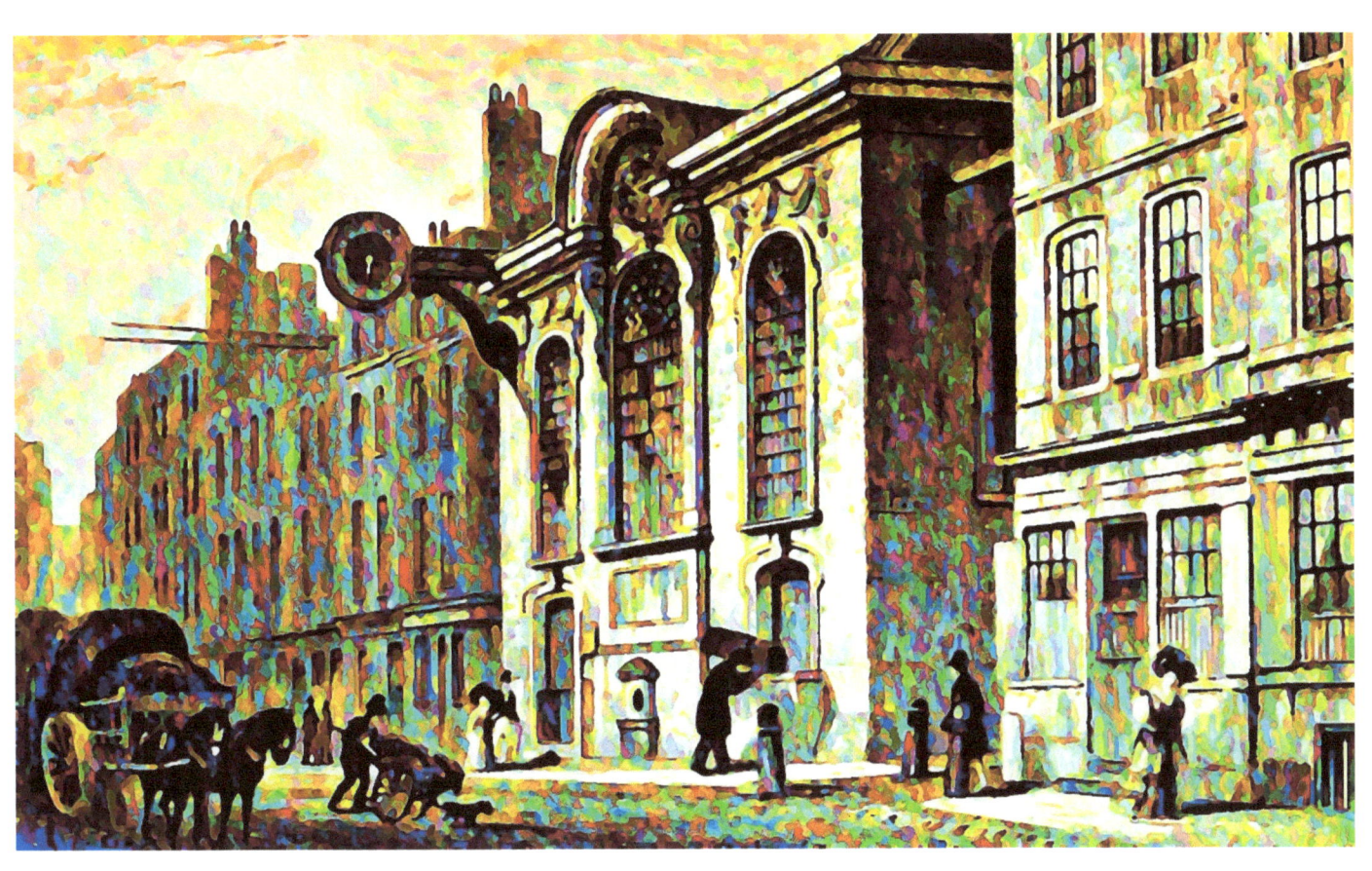

ST. SWITHIN, LONDON STONE, CANNON STREET.

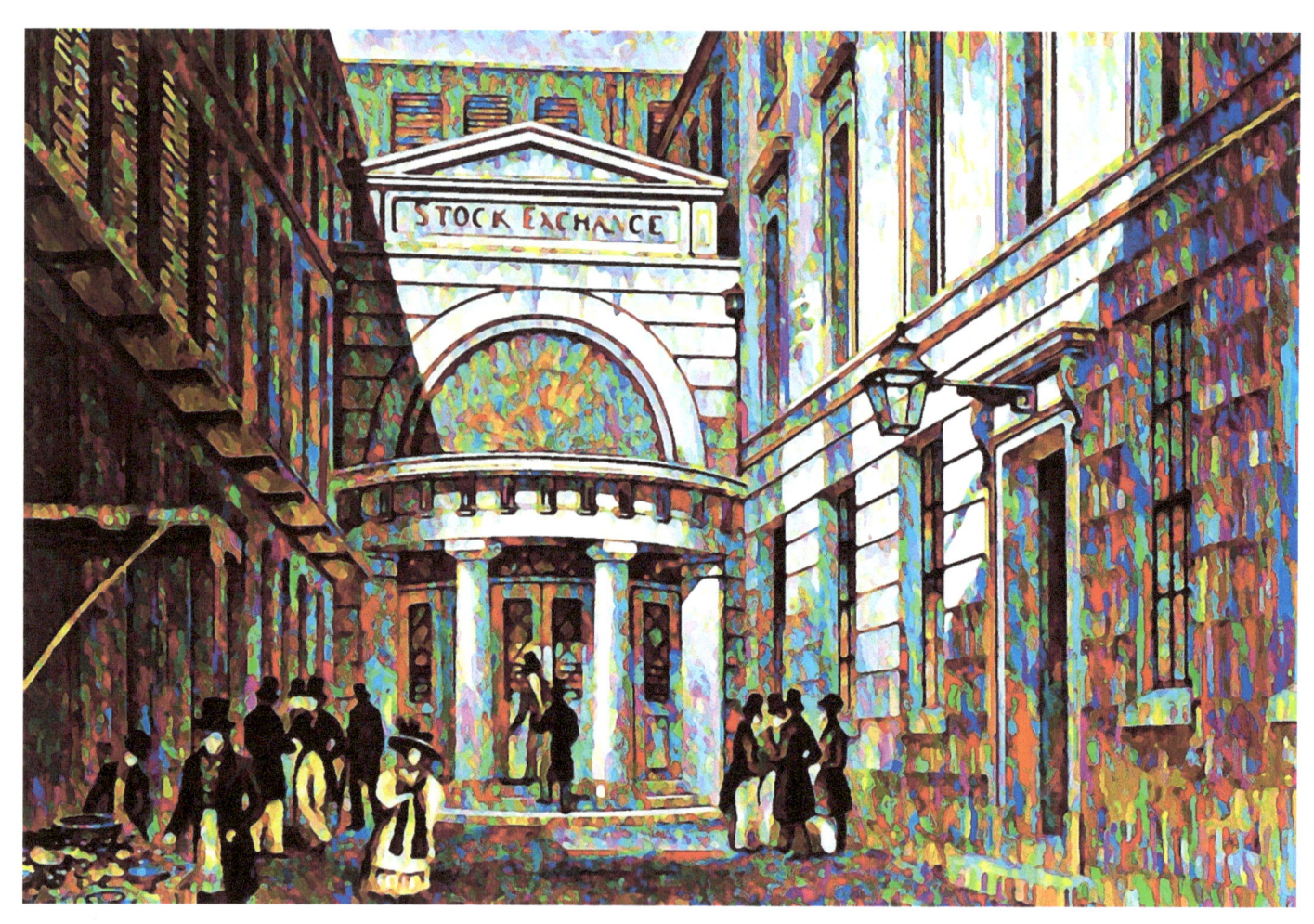

STOCK EXCHANGE

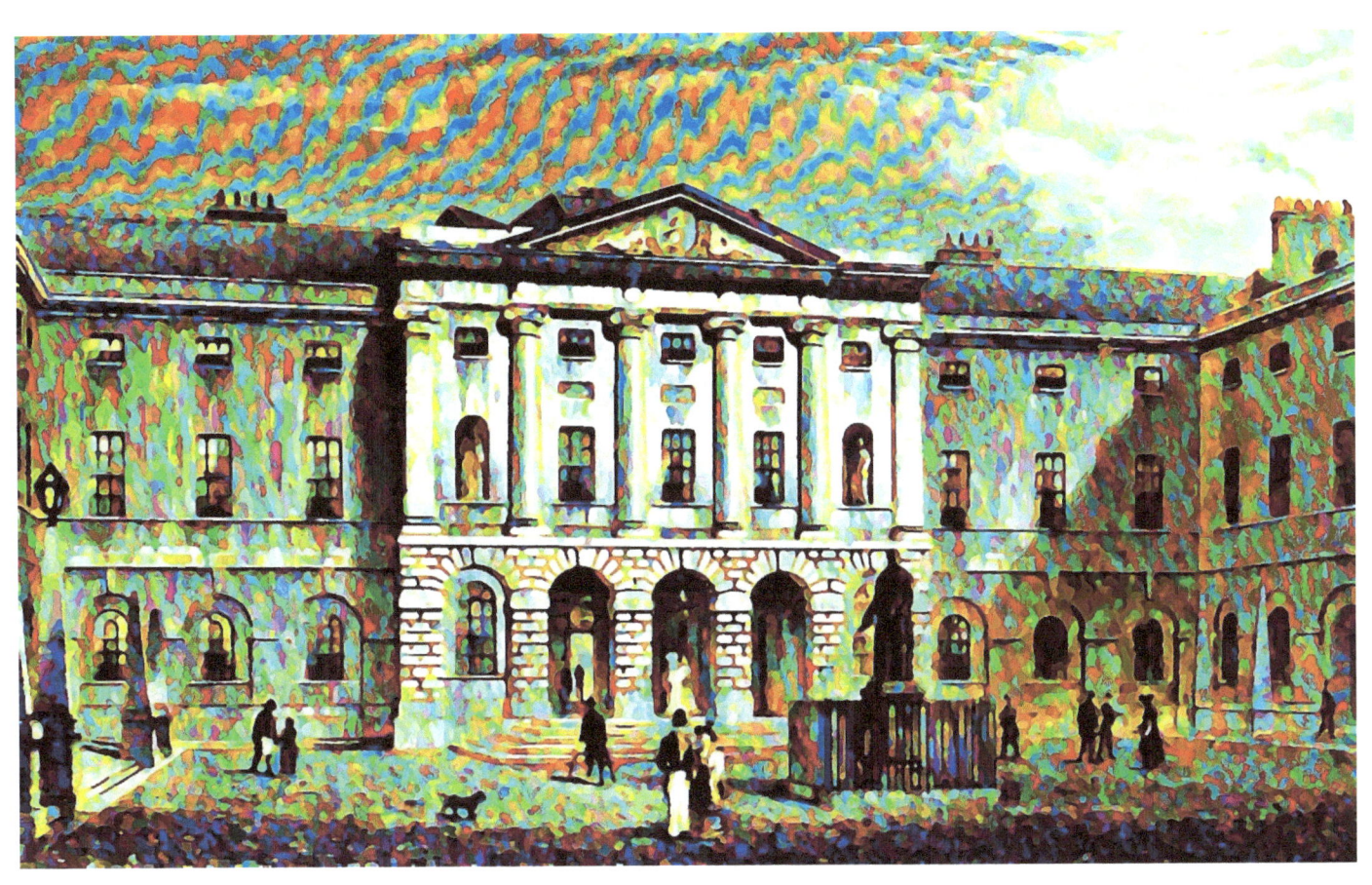

GUY'S HOSPITAL, AND STATUE OF THOMAS GUY, THE FOUNDER.

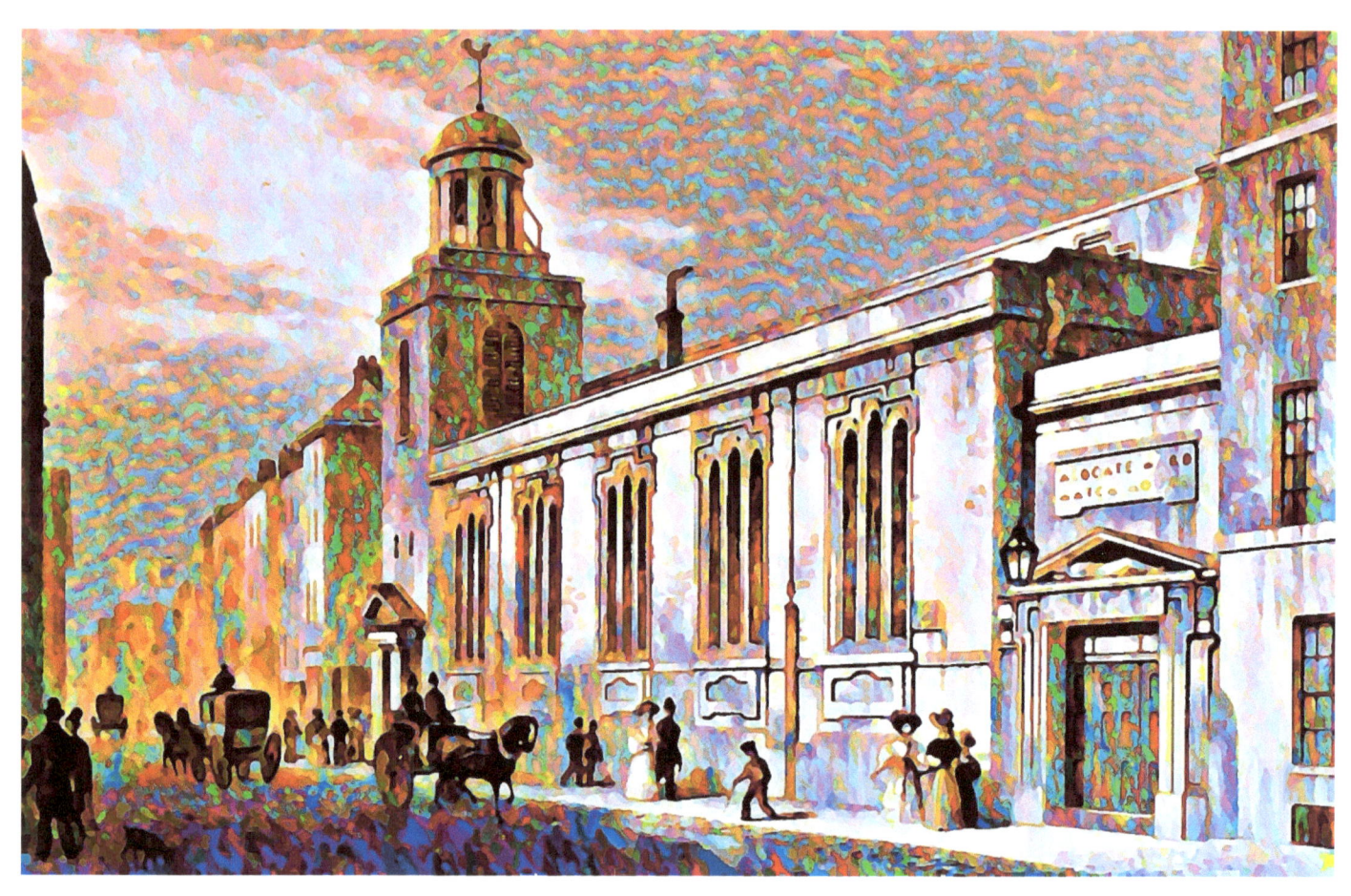

ST. CATHERINE CREE, LEADENHALL STREET.

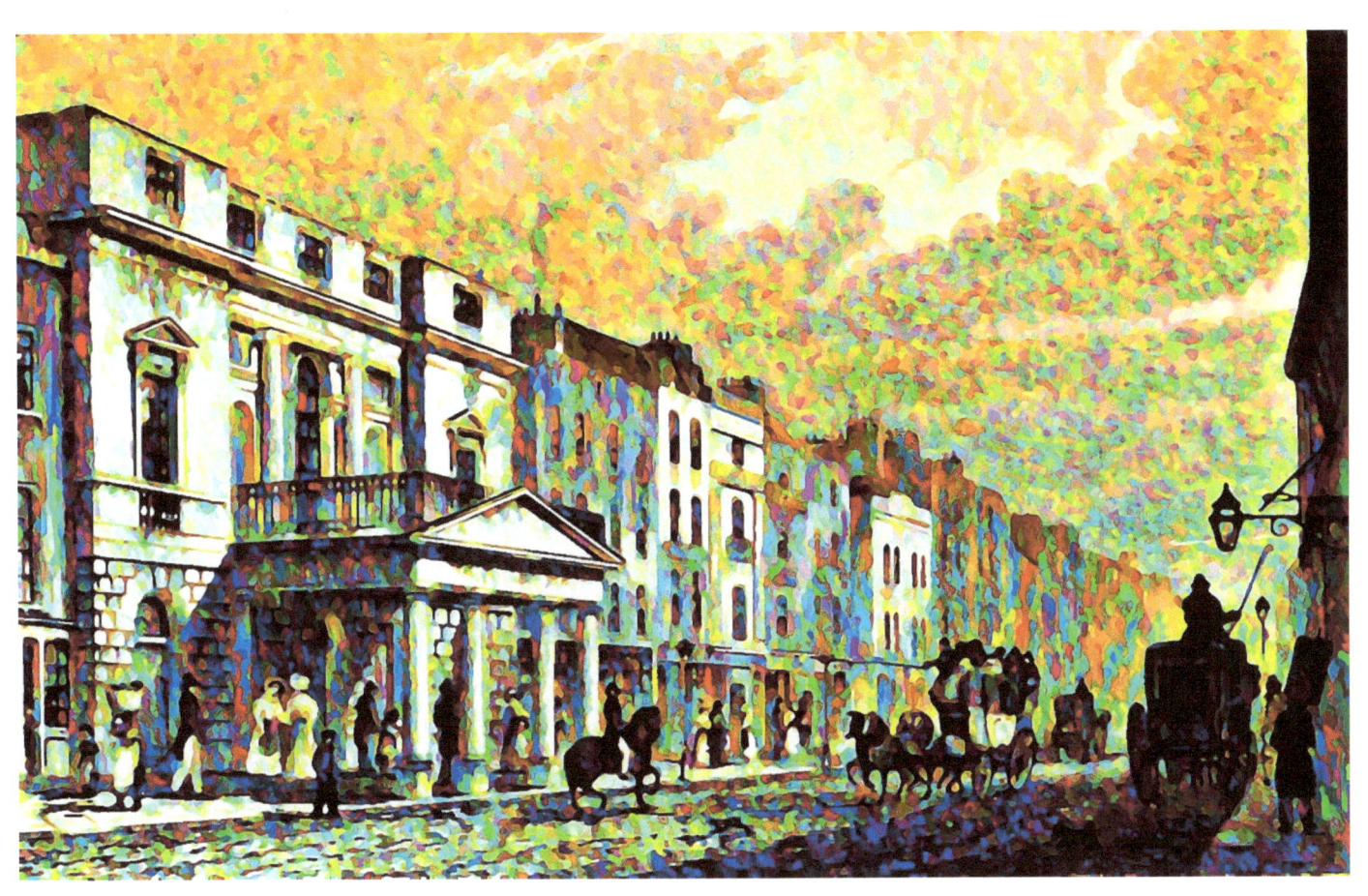

PANTHEON, OXFORD STREET.

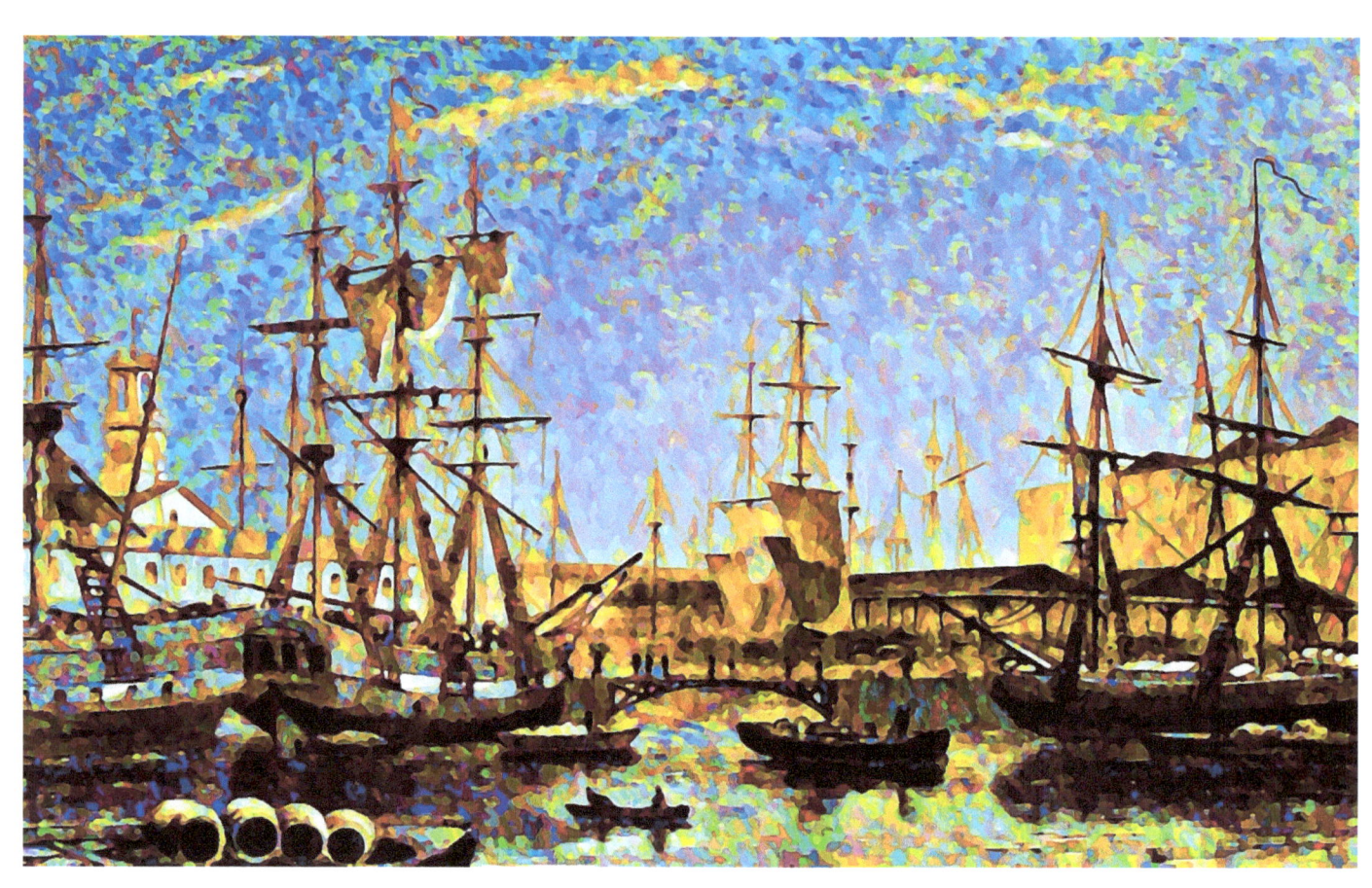

ST. KATHARINE'S DOCKS, FROM THE BASIN.

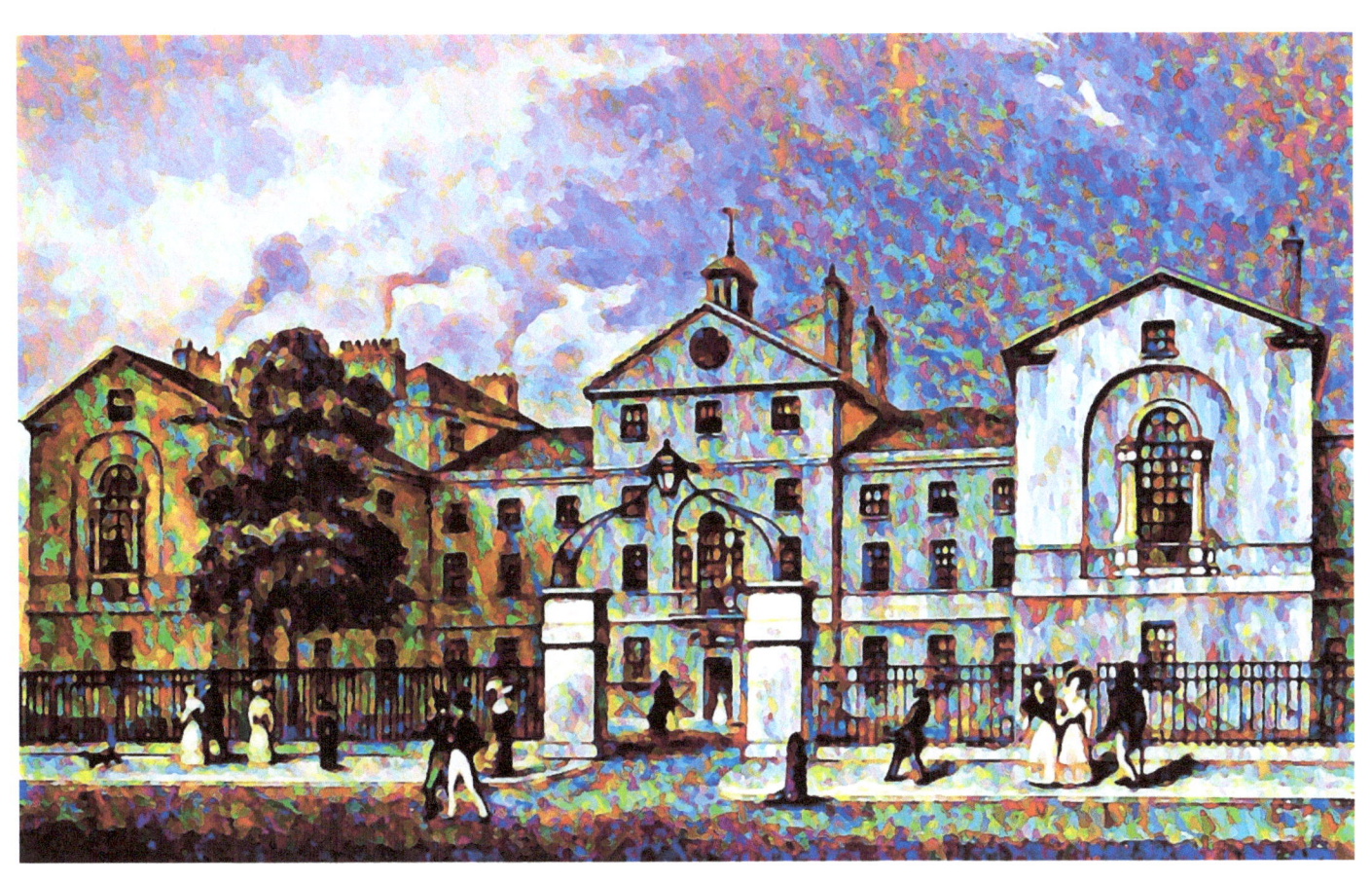

MIDDLESEX HOSPITAL.

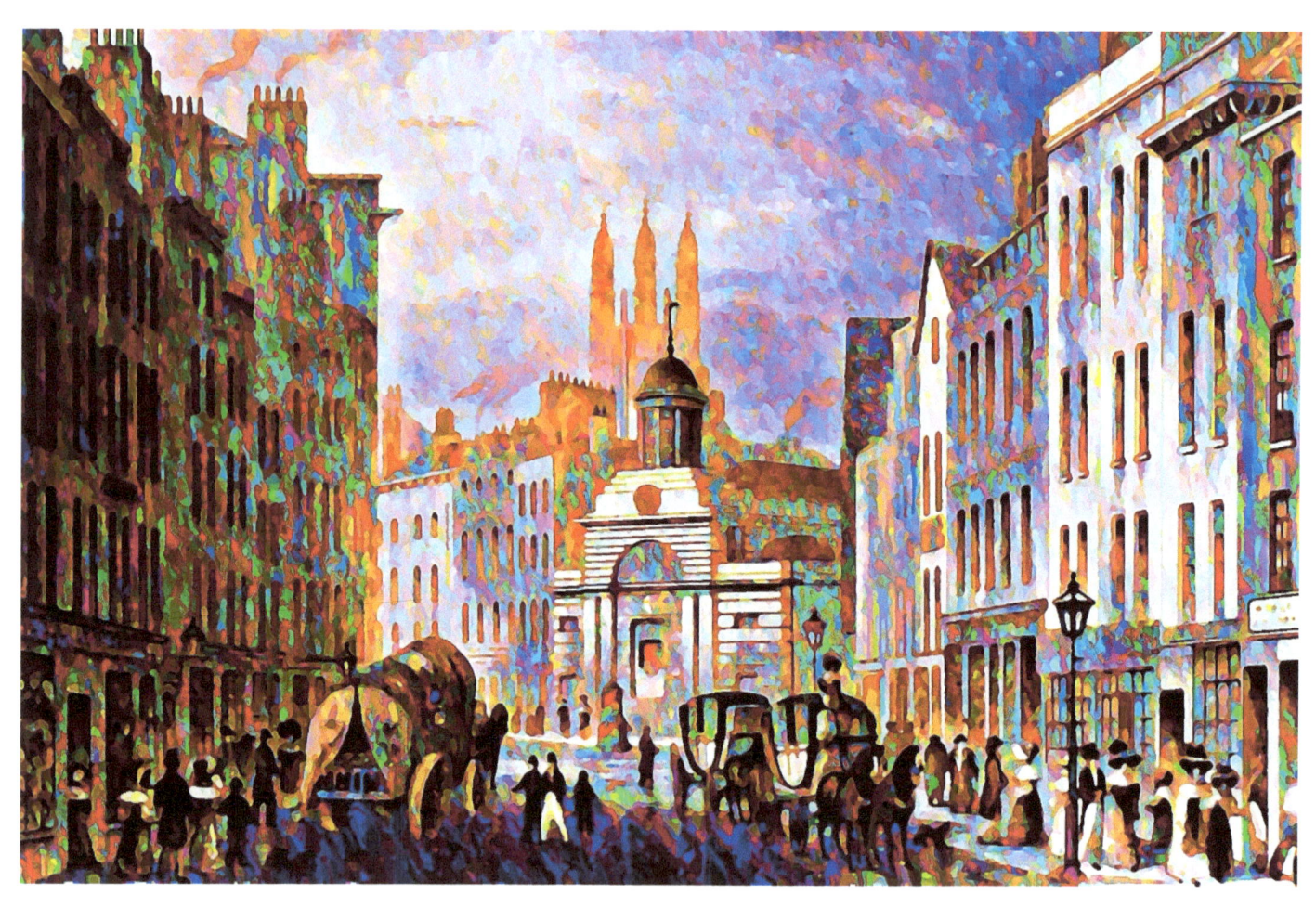

ST. MARTIN OUTWICH, BISHOPSGATE STREET.

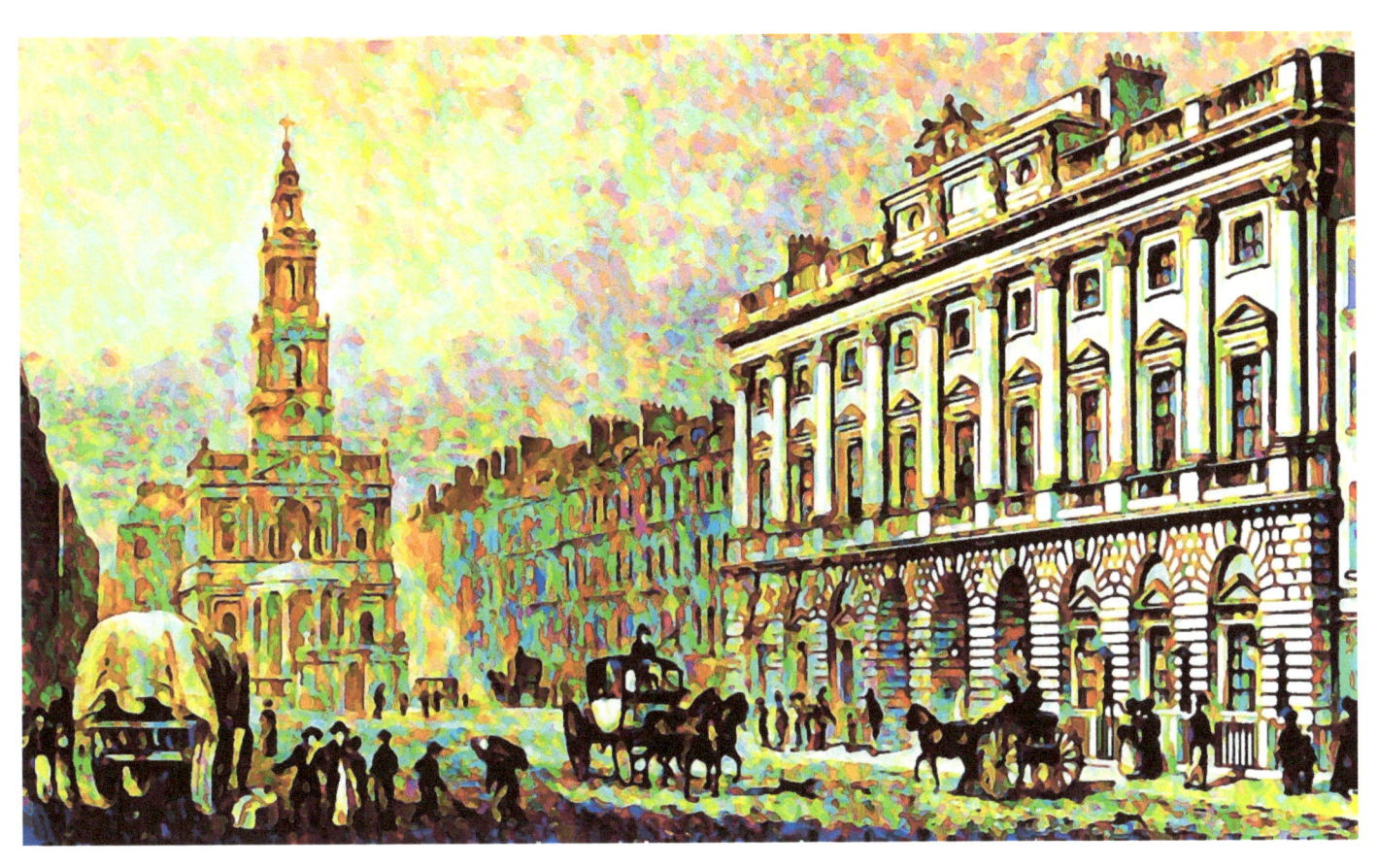

SOMERSET HOUSE, STRAND.

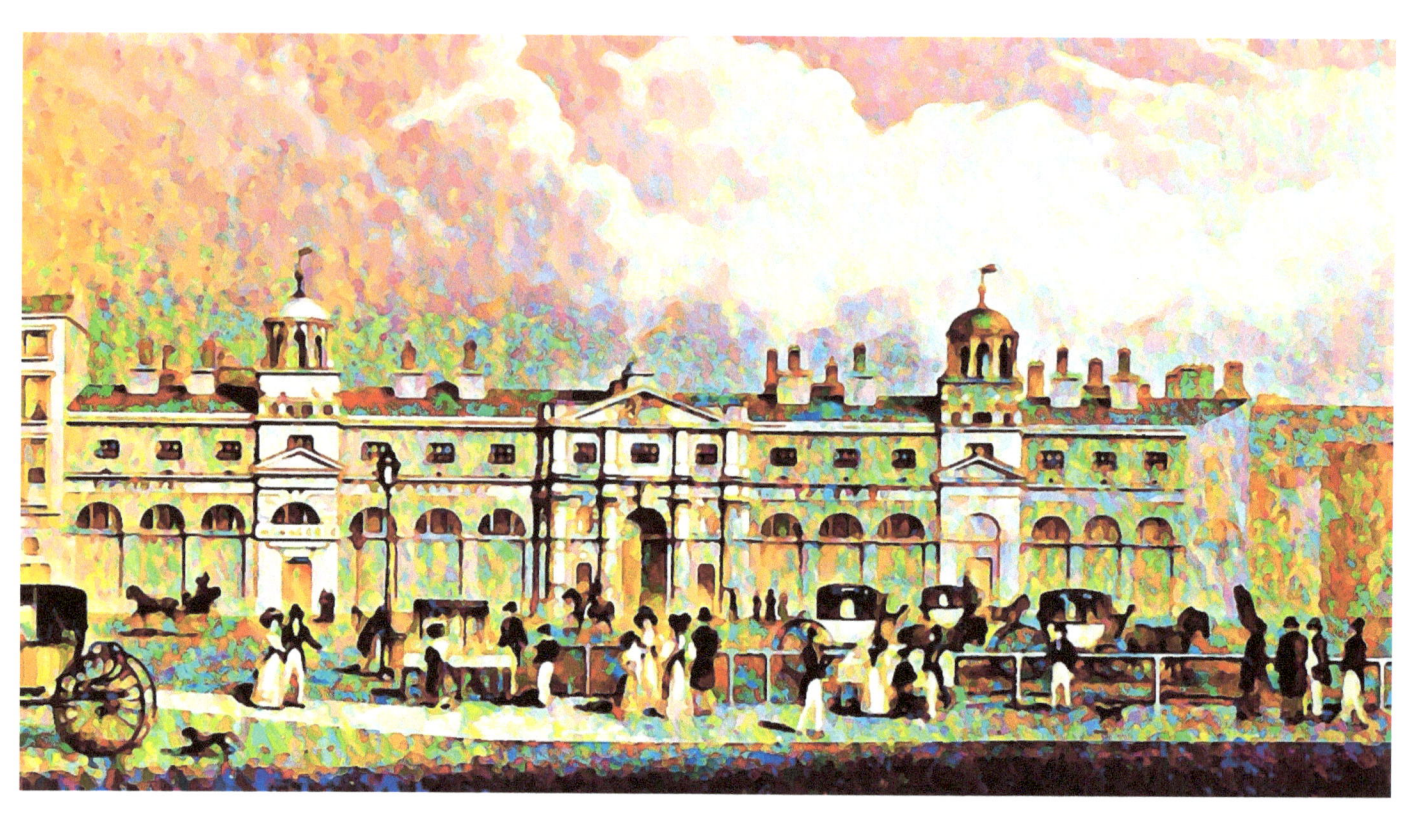

THE KING'S MEWS, CHARING CROSS.

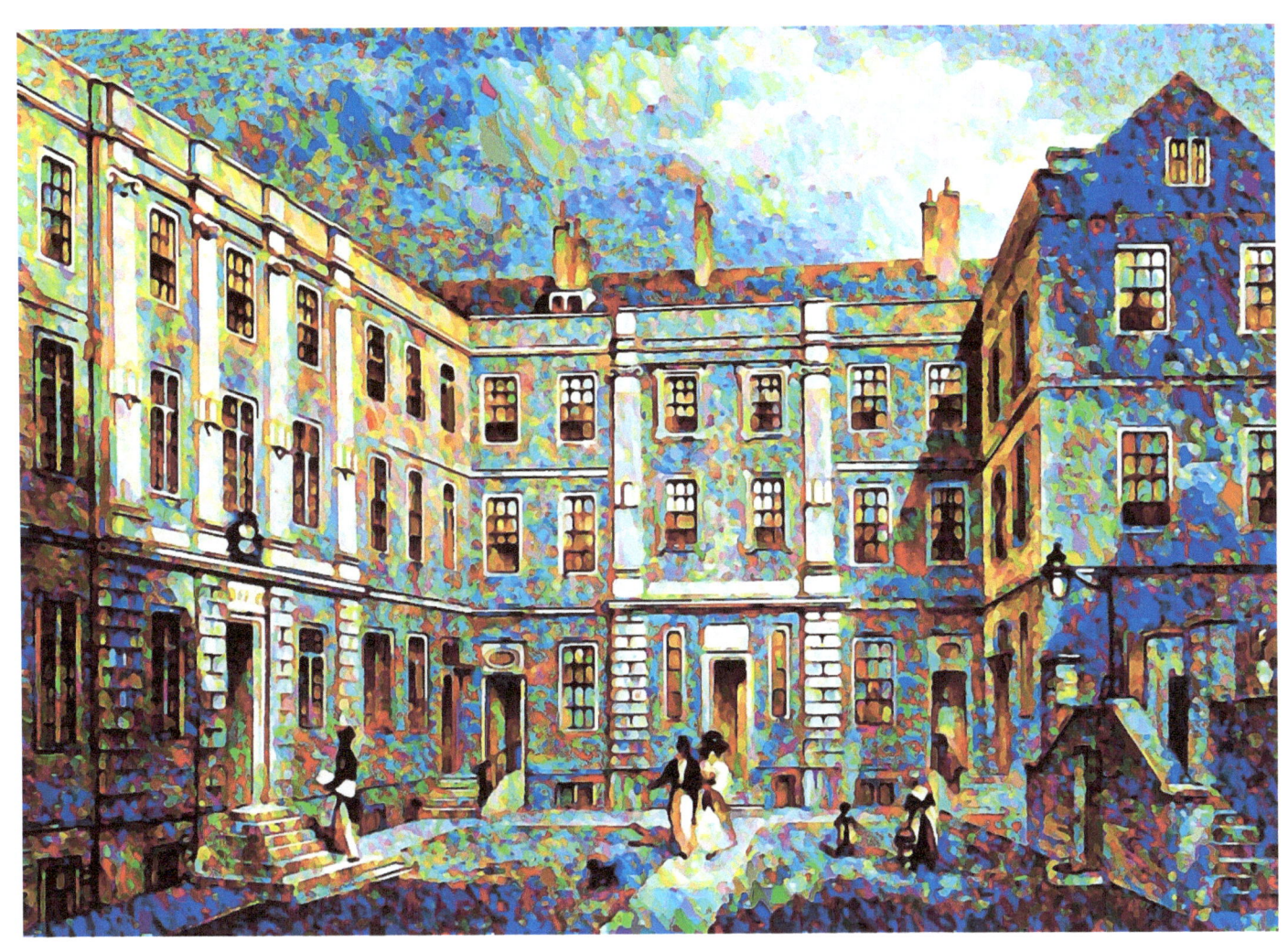

HERALD'S COLLEGE, BENNET'S HILL.

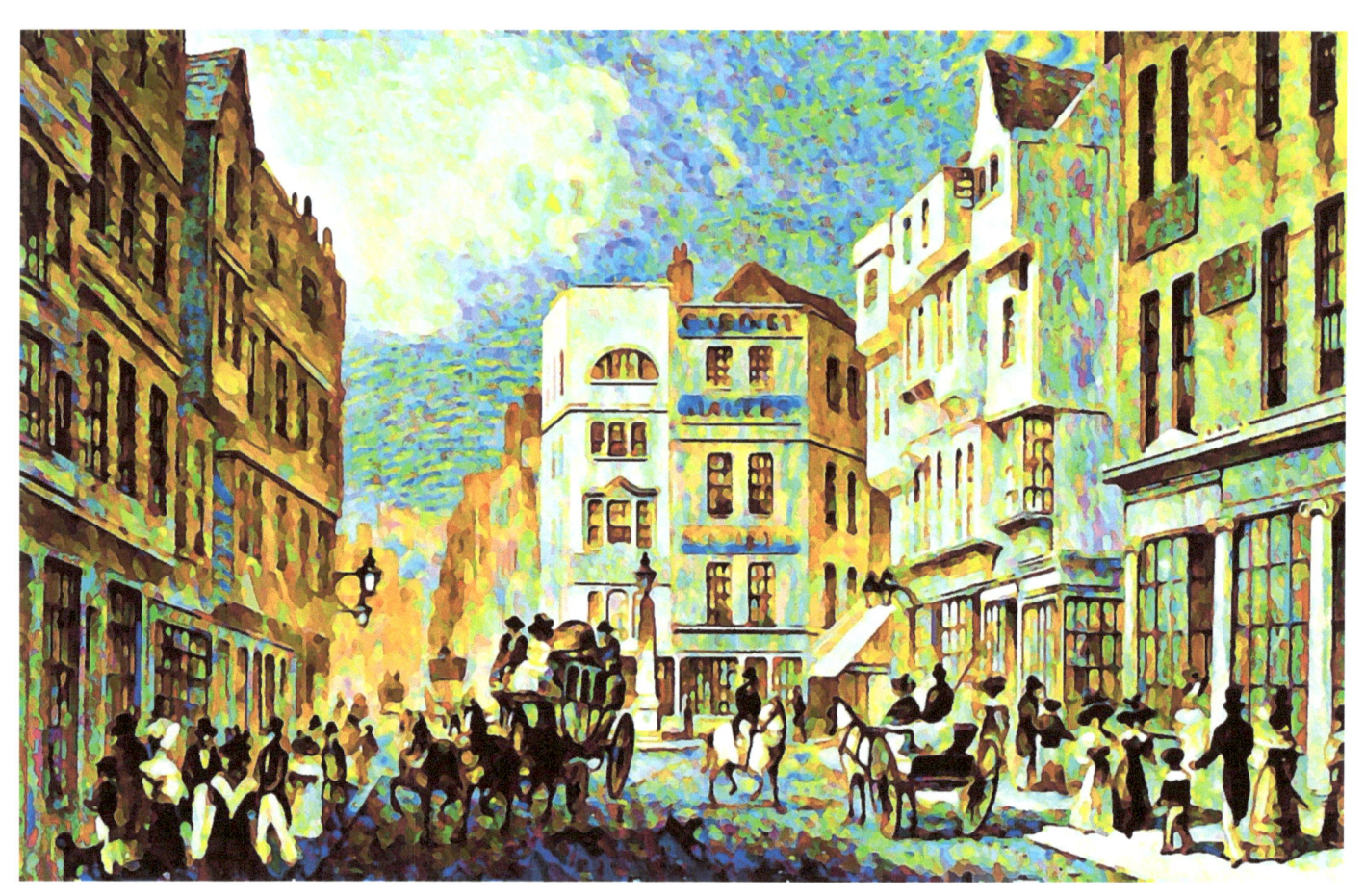

ALDGATE.

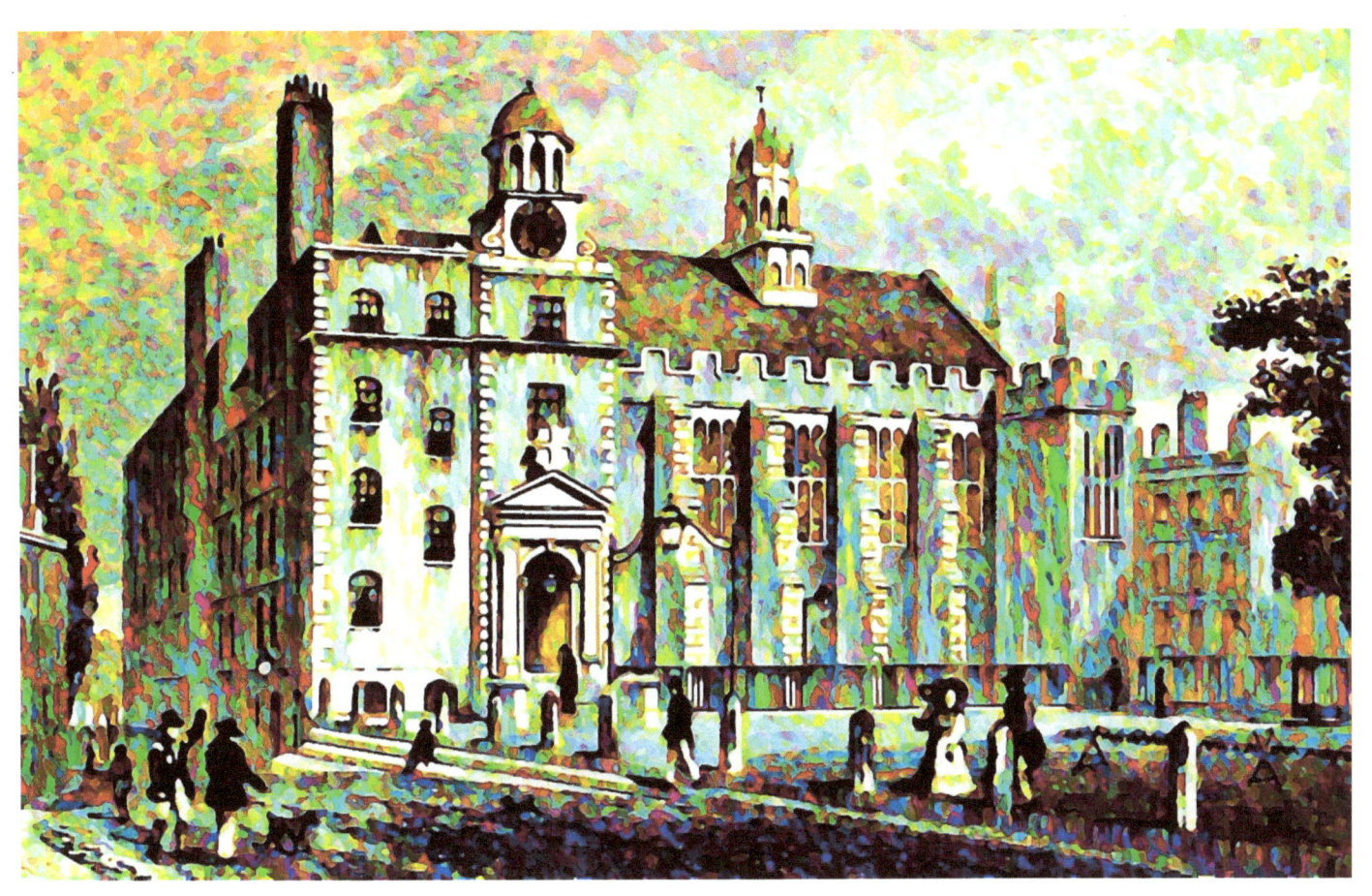

MIDDLE TEMPLE HALL.

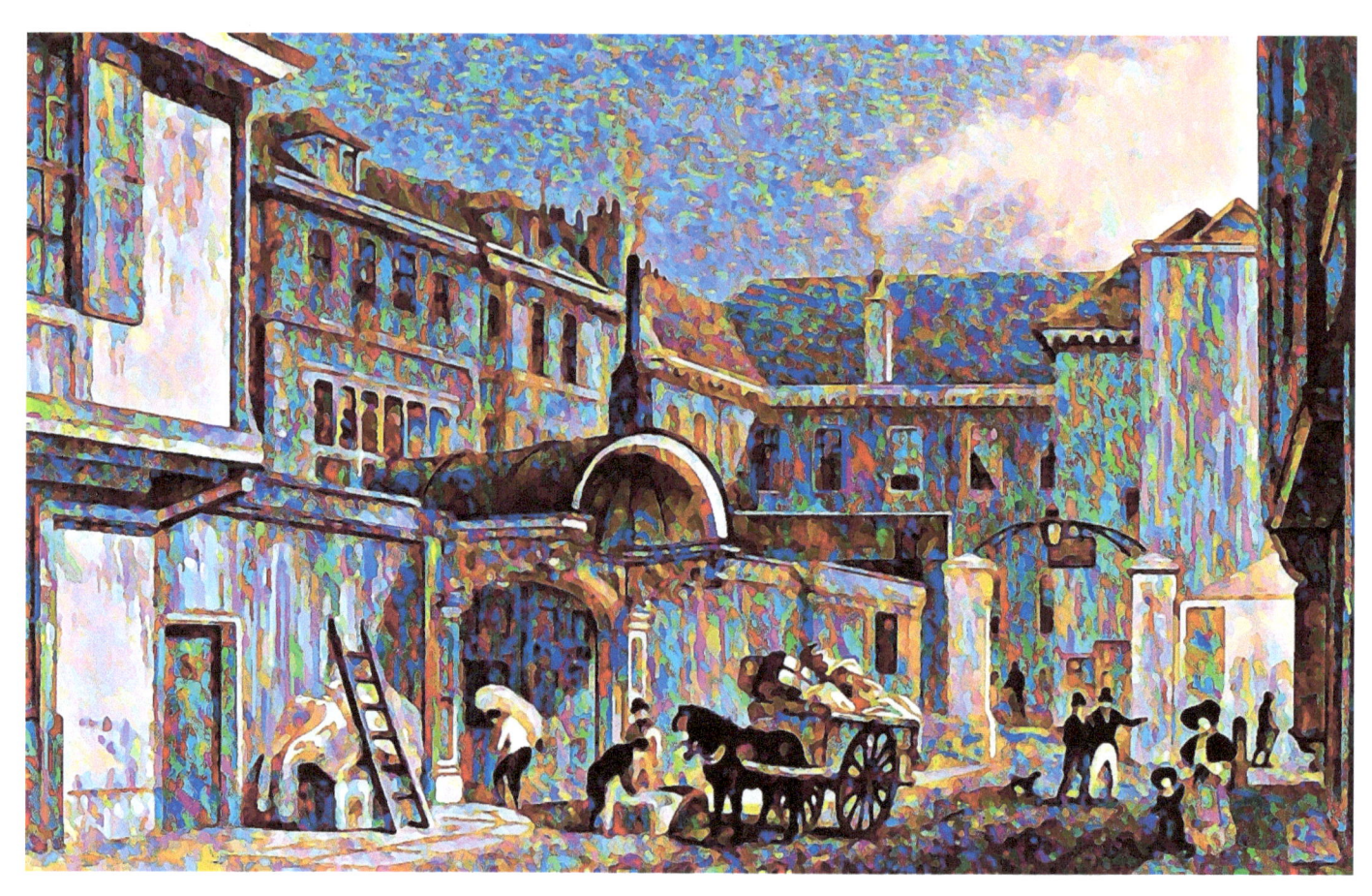

WINCHESTER HOUSE, WINCHESTER STREET.

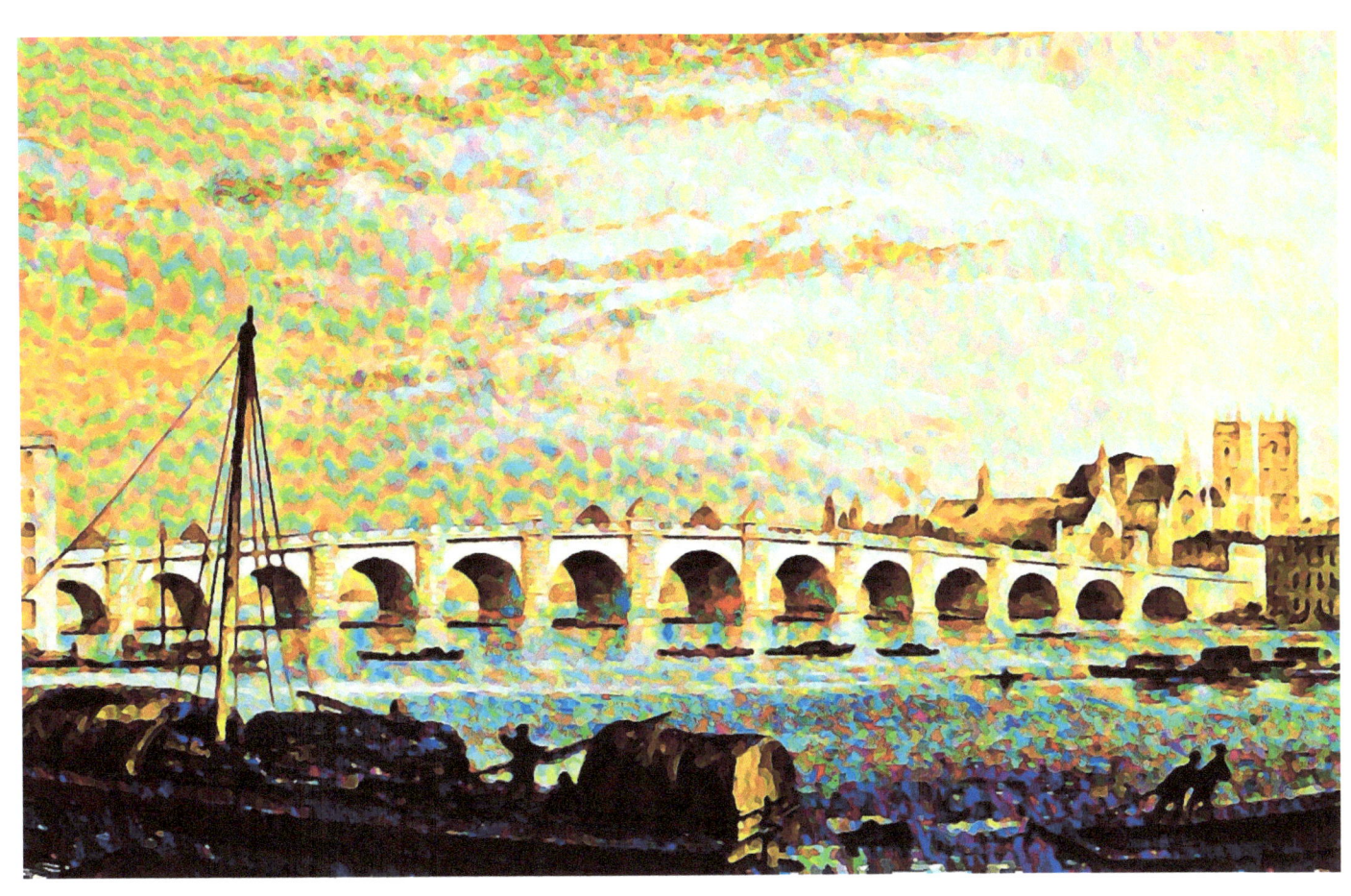

WESTMINSTER BRIDGE.

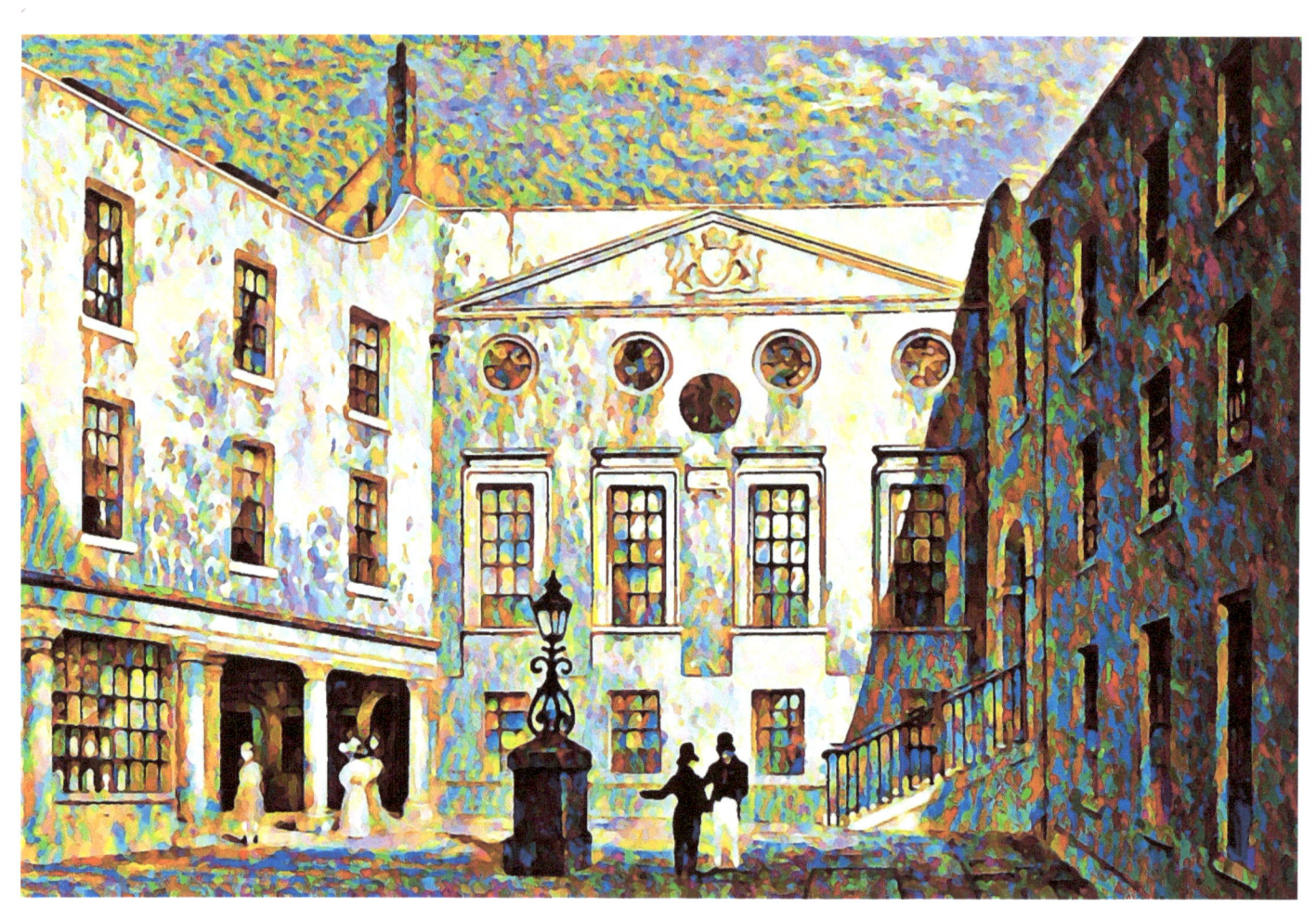

APOTHECARIES' HALL, PILGRIM STREET, BLACKFRIARS.

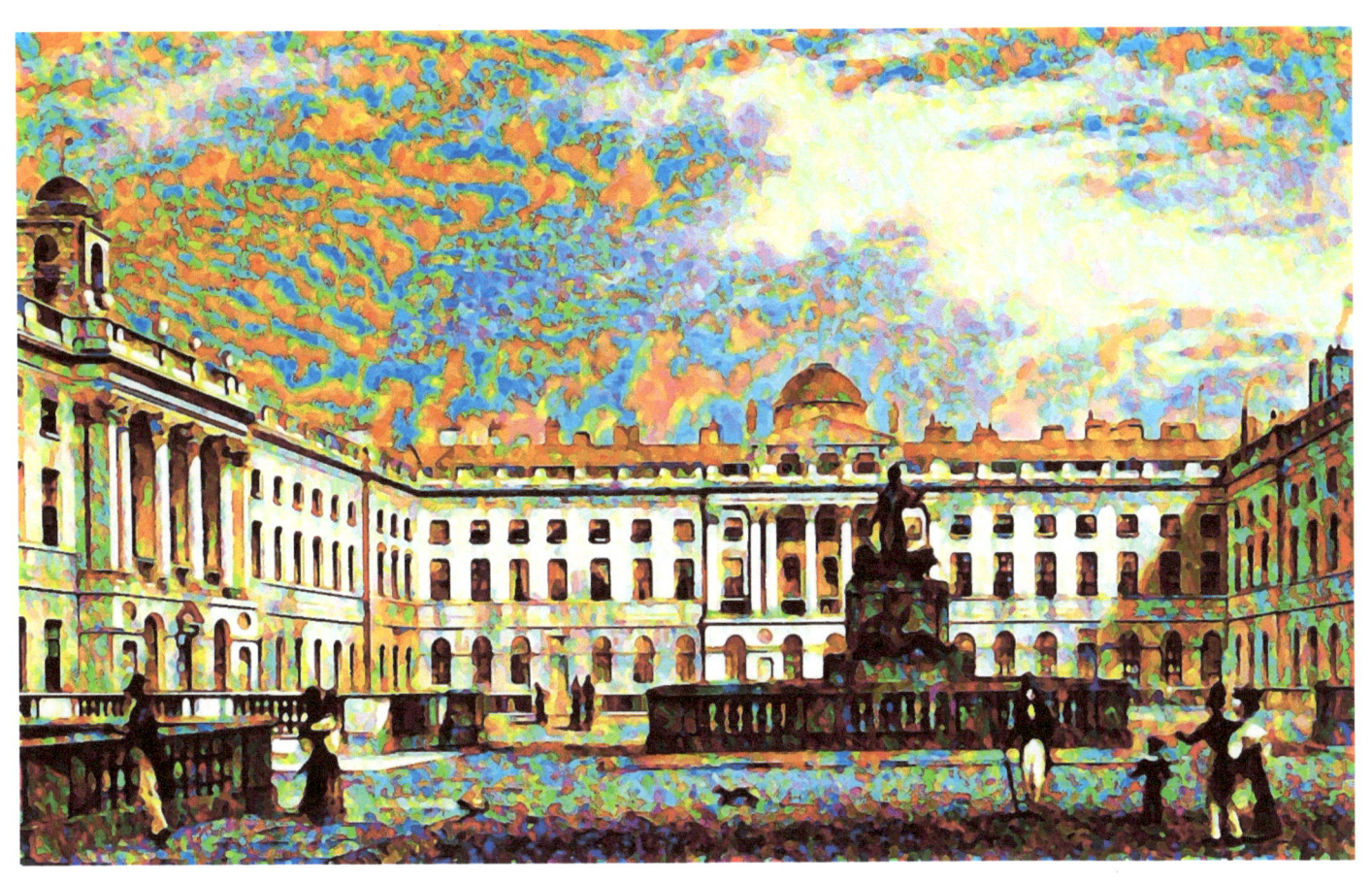

INTERIOR QUADRANGLE, SOMERSET HOUSE.

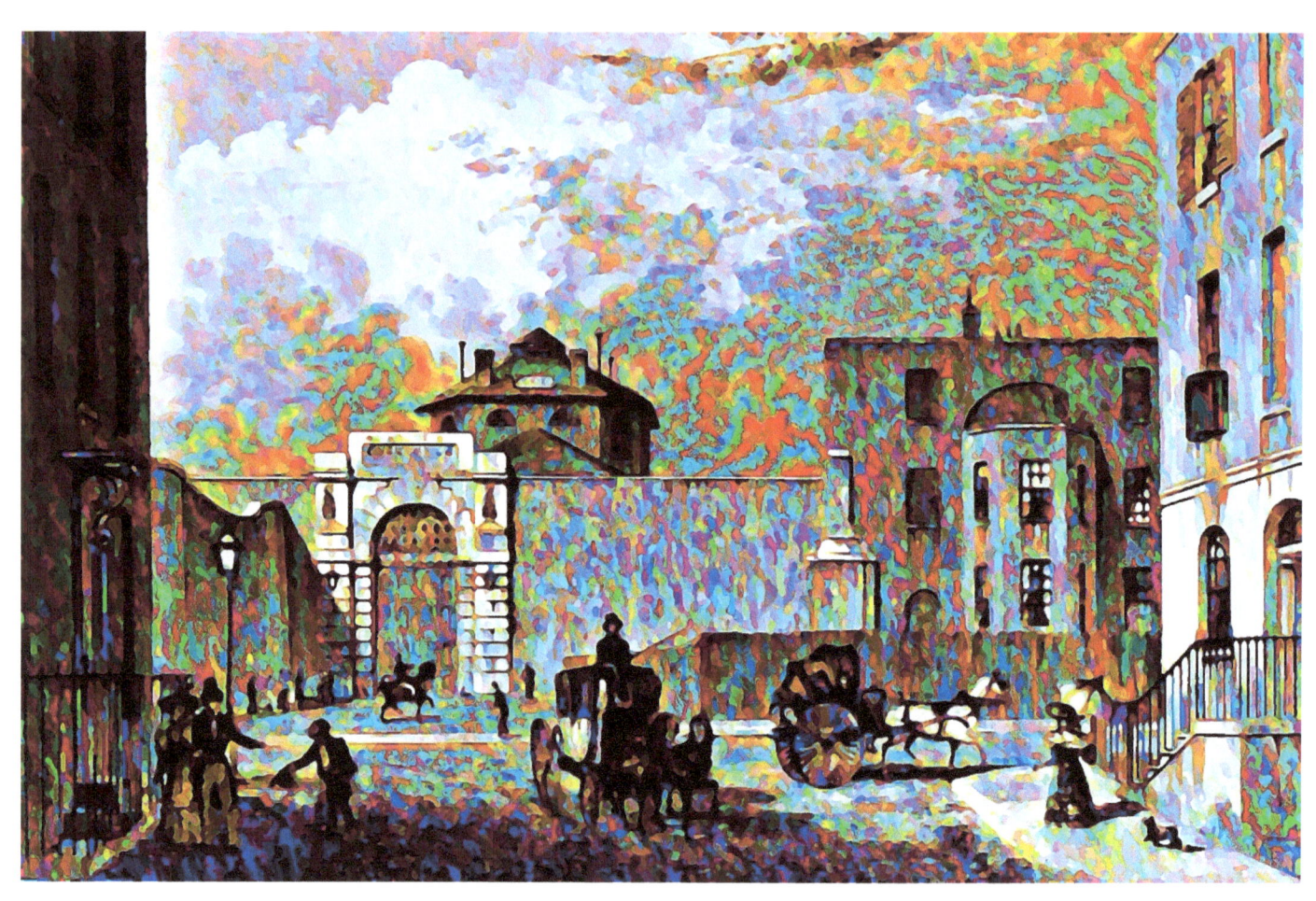

HOUSE OF CORRECTION, COLDBATH FIELDS.

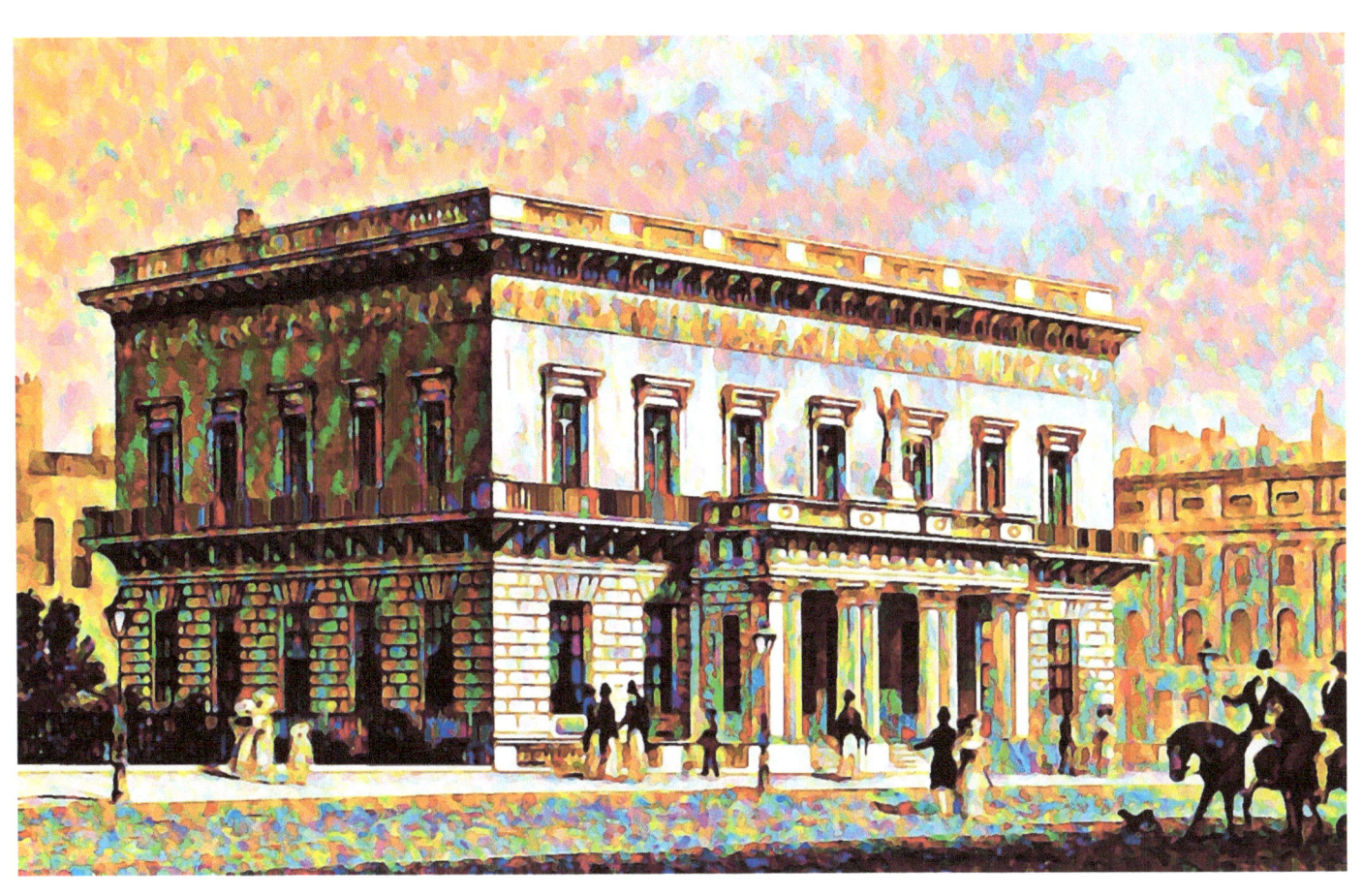

THE NEW ATHENAEUM, WATERLOO PLACE.

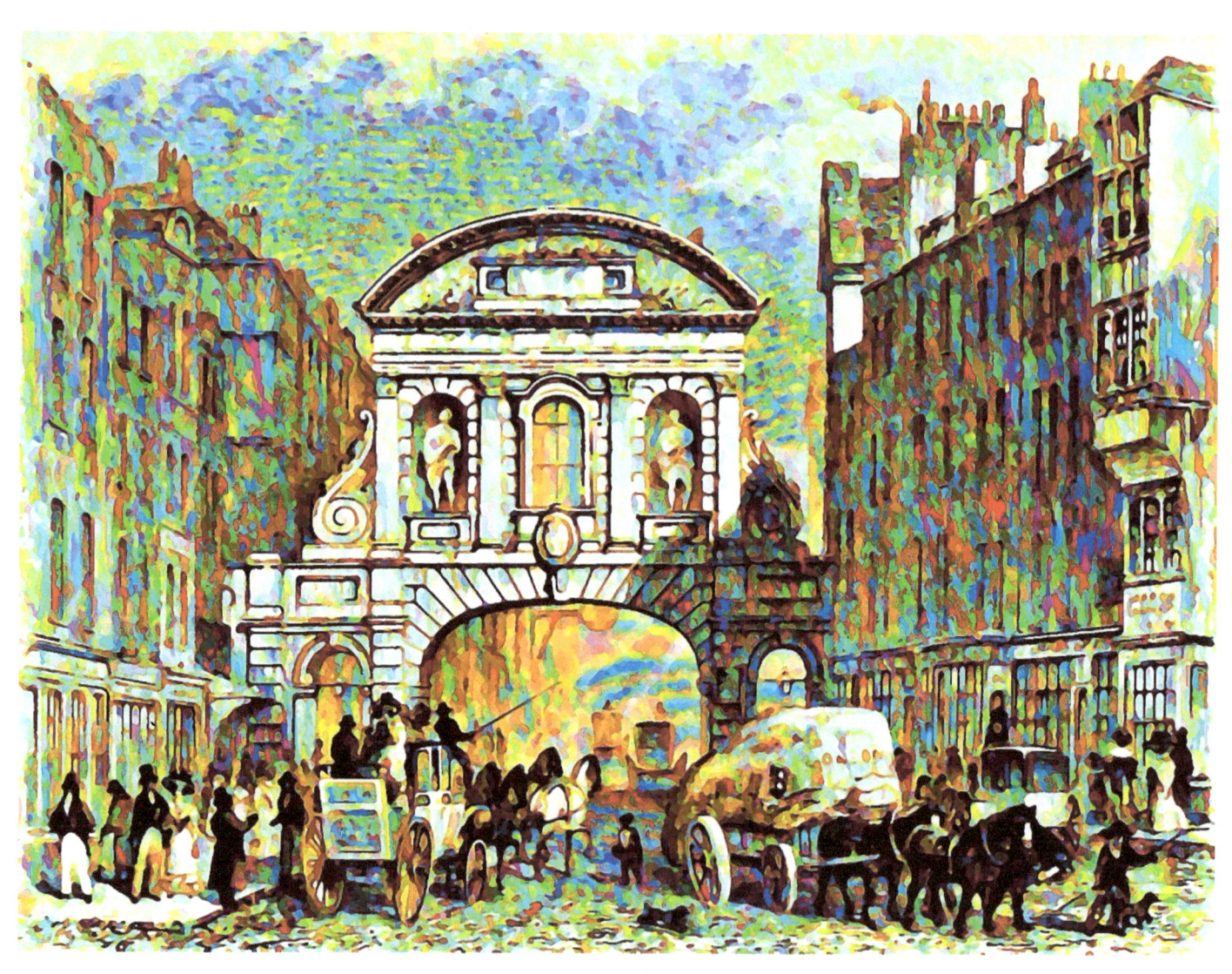

TEMPLE BAR, FROM THE STRAND.

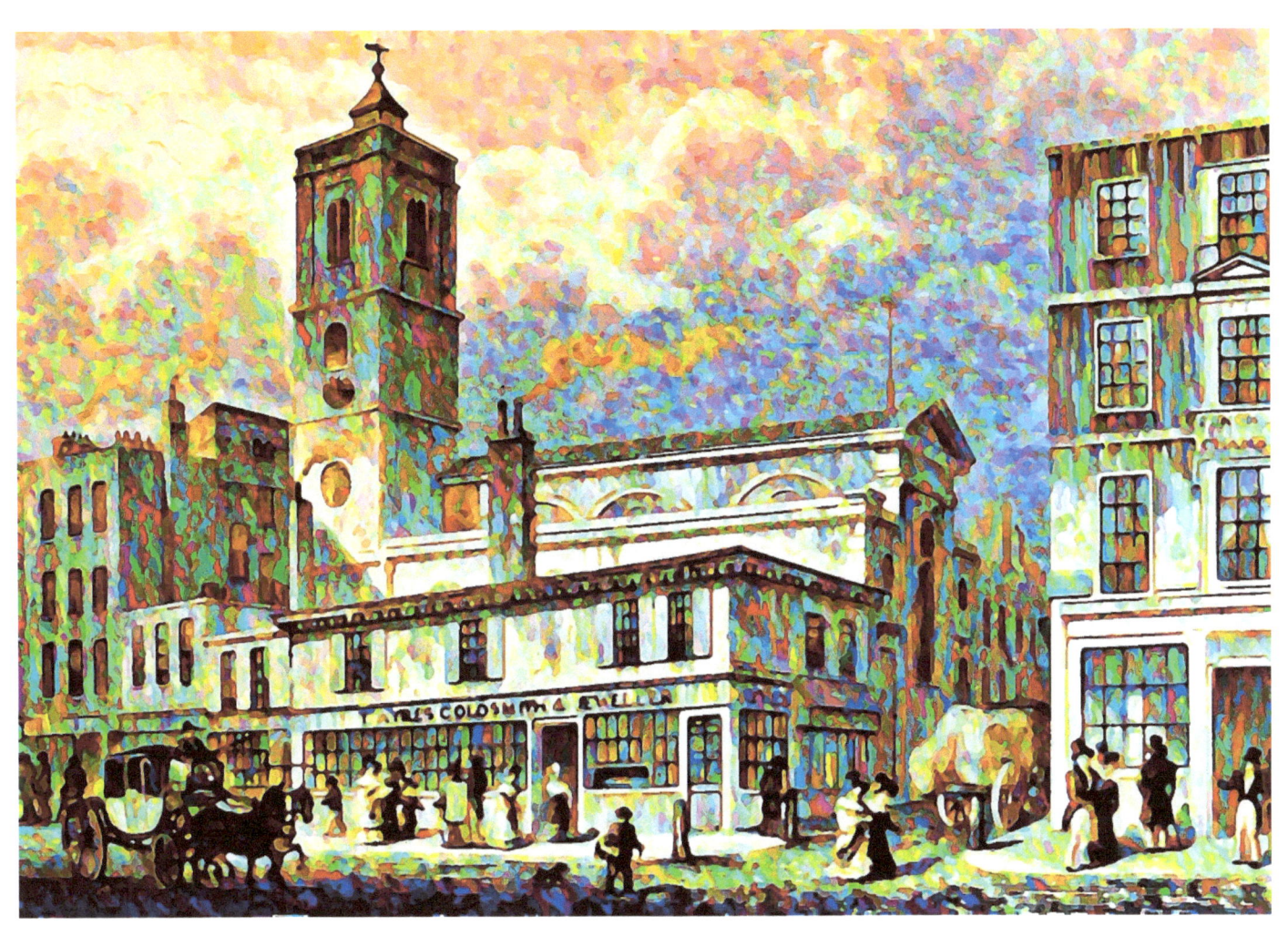

ST. DIONIS BACKCHURCH, FENCHURCH STREET.

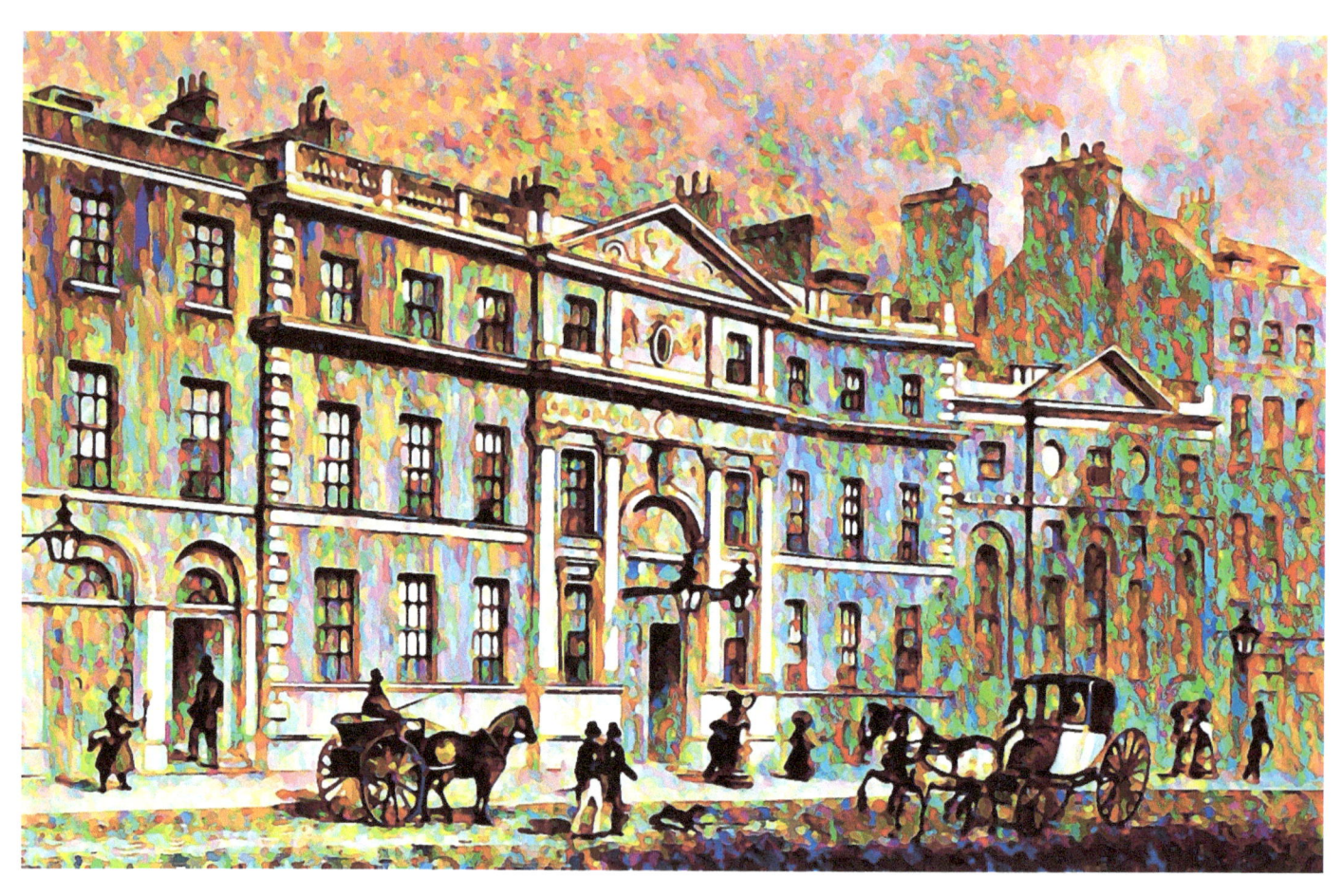

DRAPERS' HALL, THROGMORTON STREET.

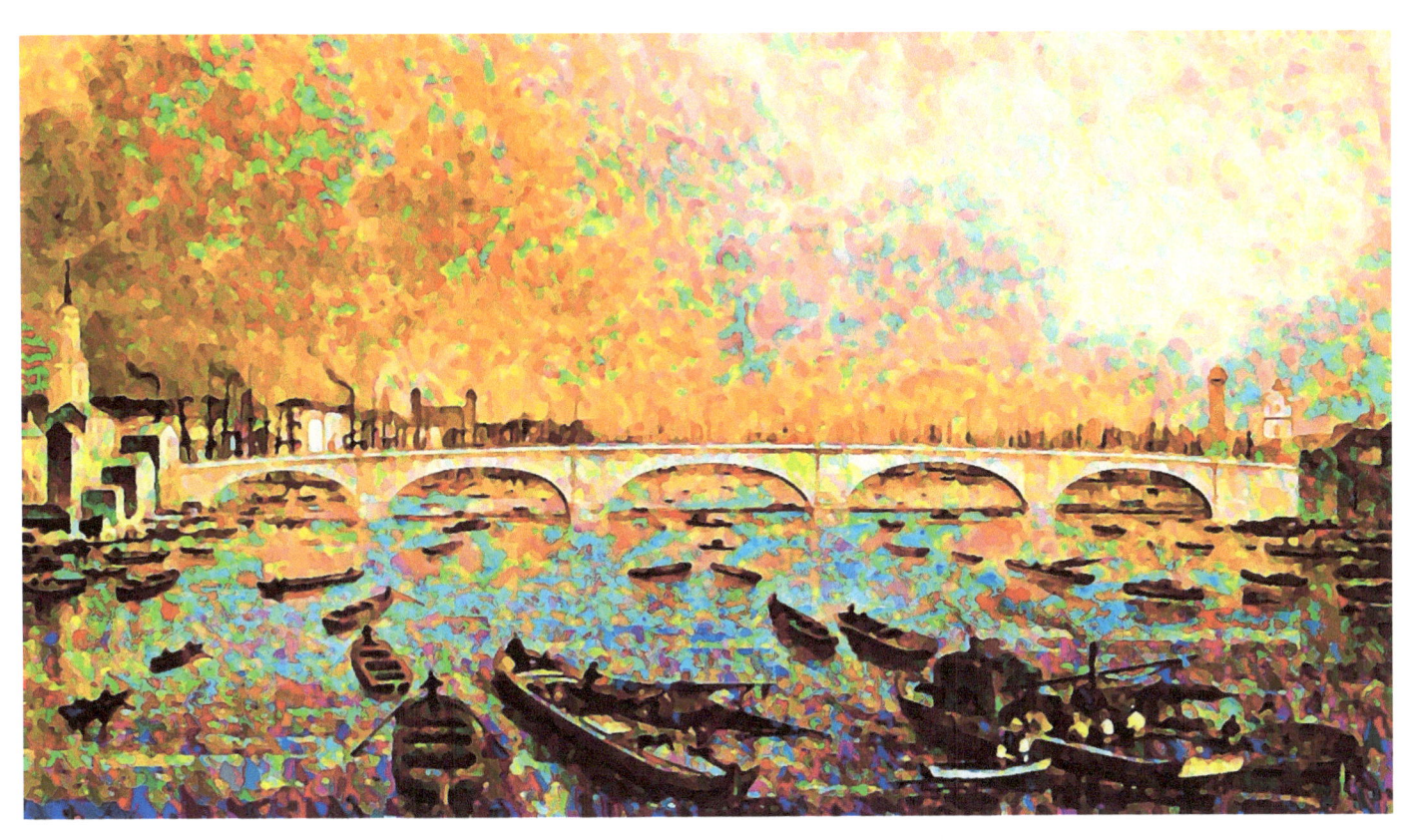

NEW LONDON BRIDGE.

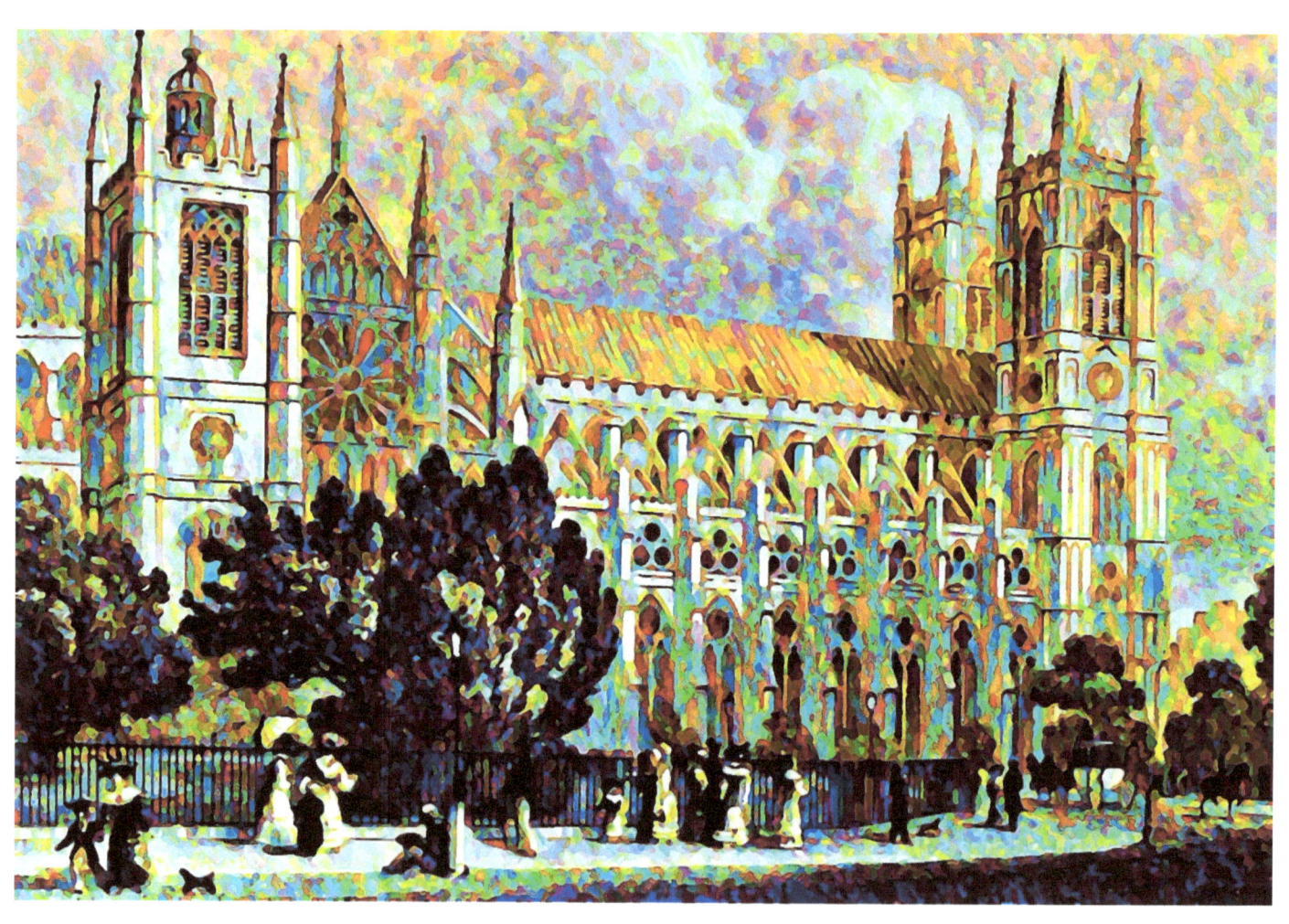

WESTMINSTER ABBEY, AND ST. MARGARET'S CHURCH.

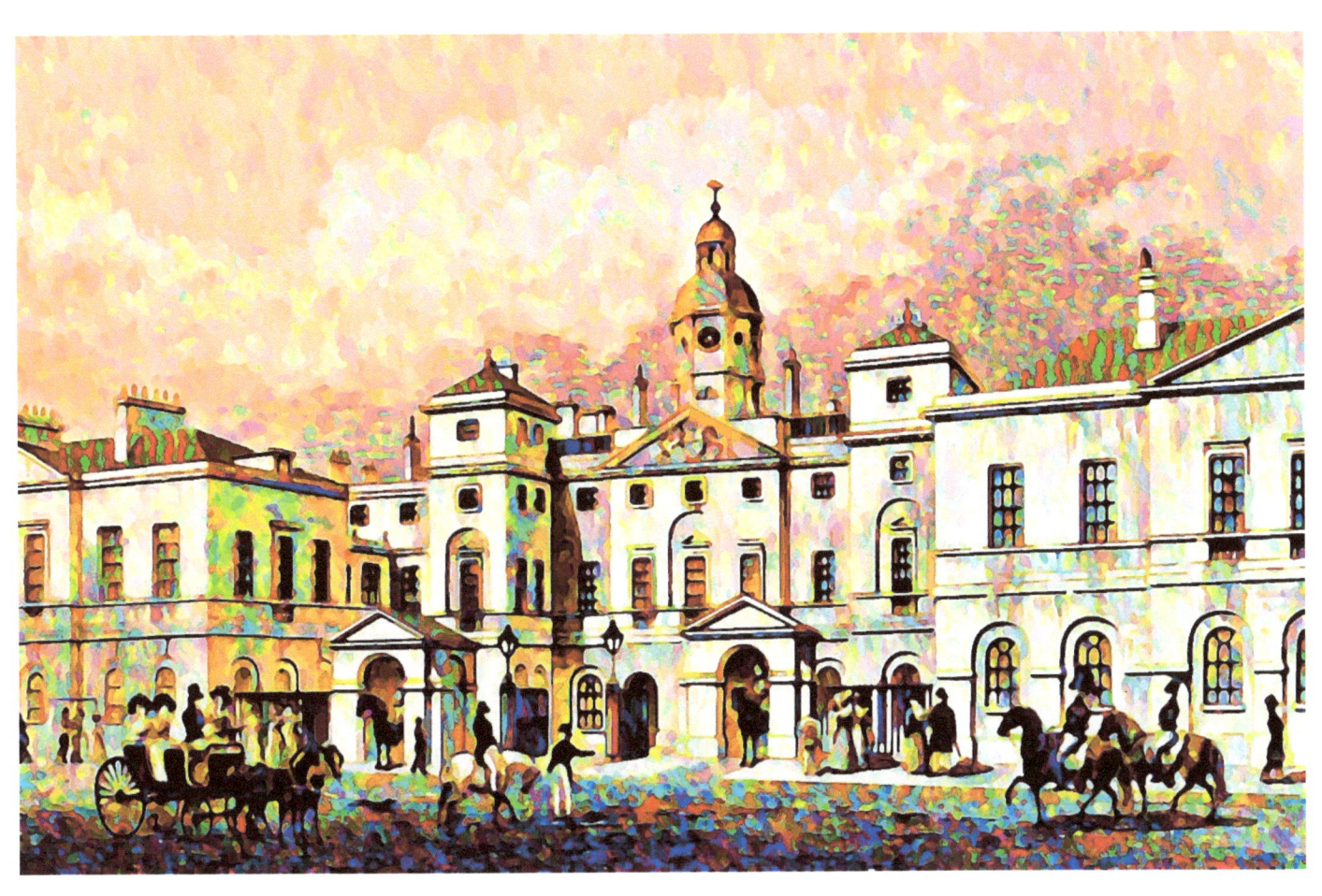

HORSE GUARDS, PARLIAMENT STREET.

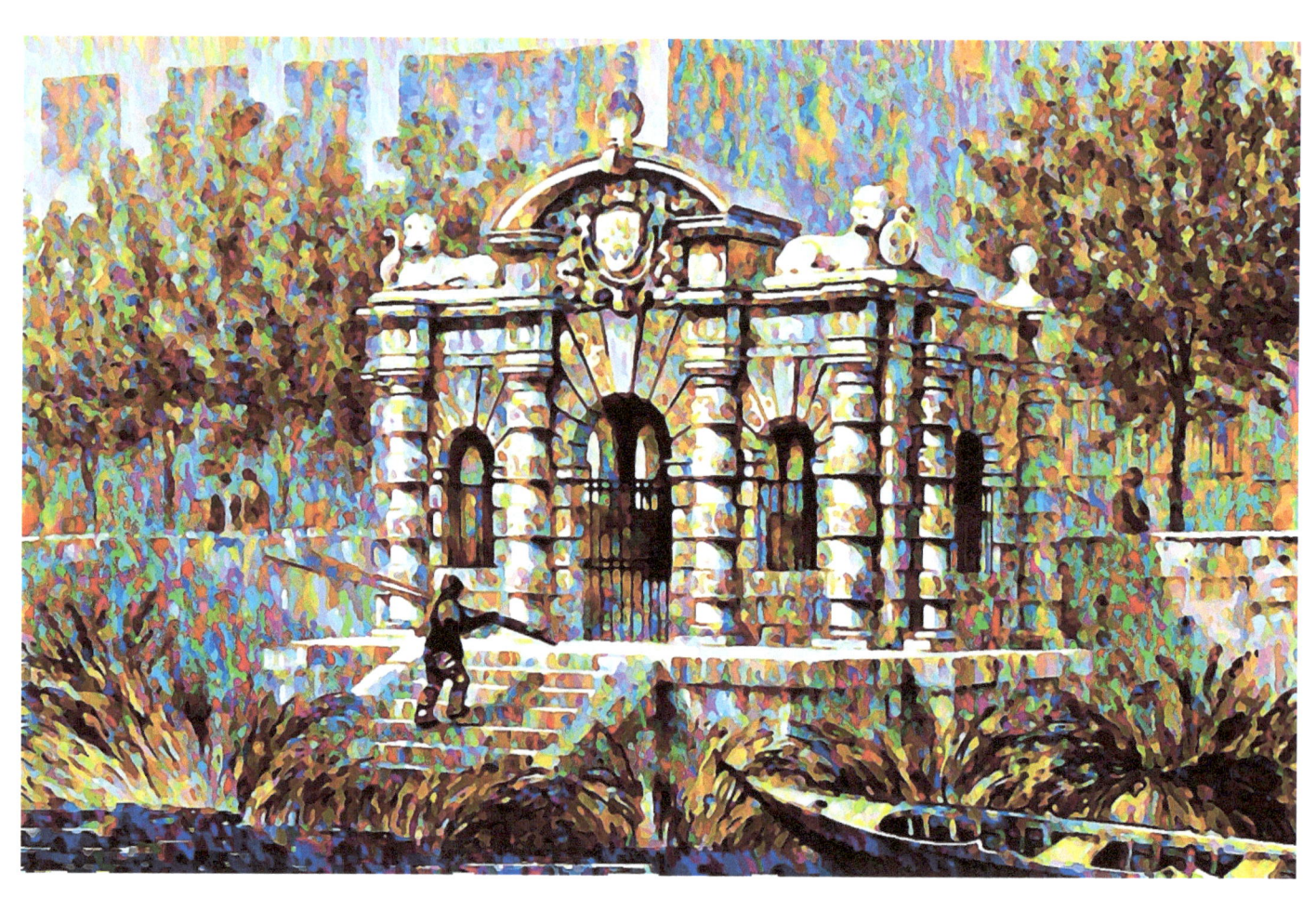

BUCKINGHAM WATER GATE, STRAND.

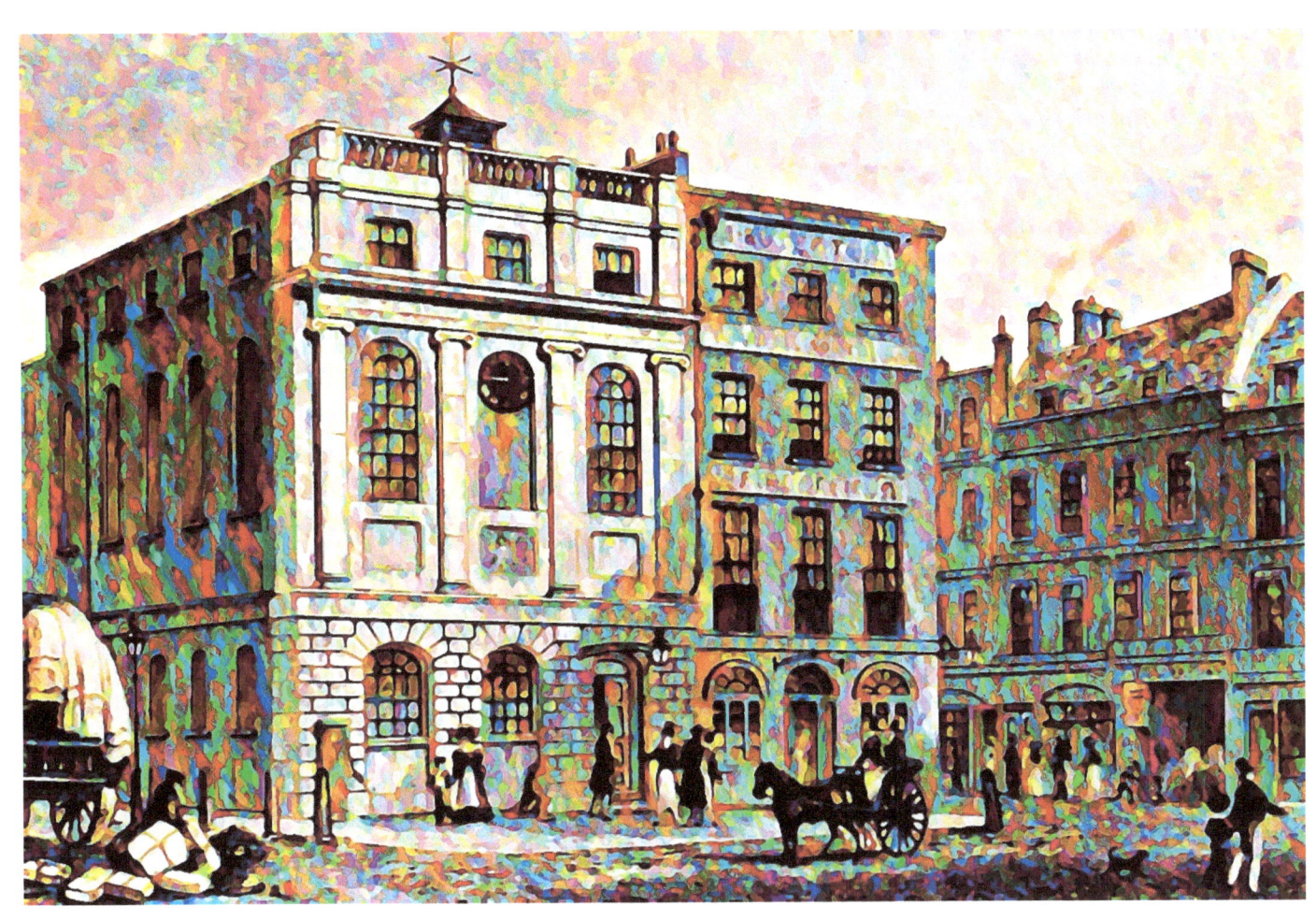

TOWN HALL, BOROUGH HIGH STREET.

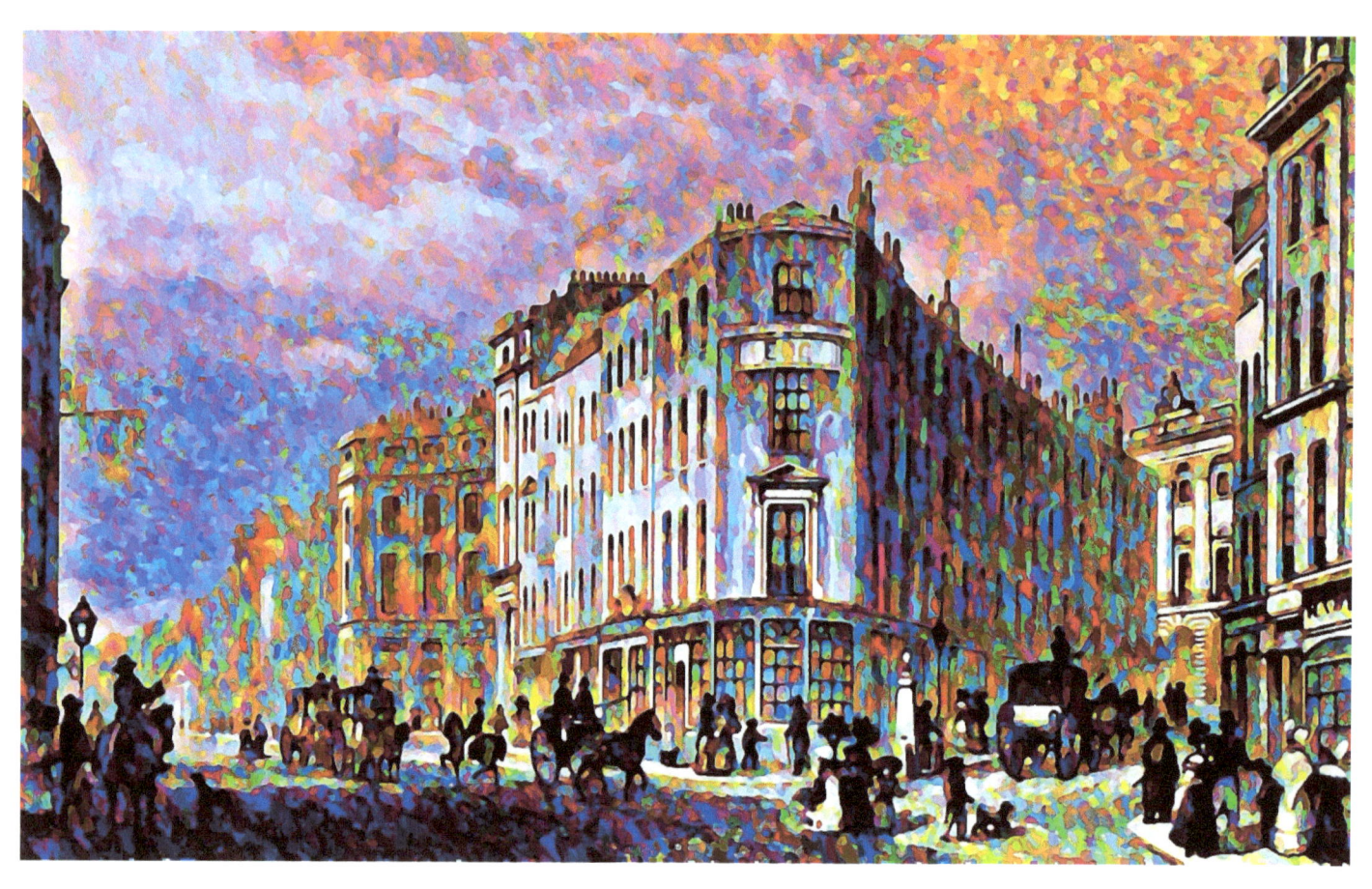

PICCADILLY, FROM COVENTRY STREET.

www.ingramcontent.com/pod-product-compliance
Lightning Source LLC
Chambersburg PA
CBHW051102180526
45172CB00002B/746